Best Loved Poems

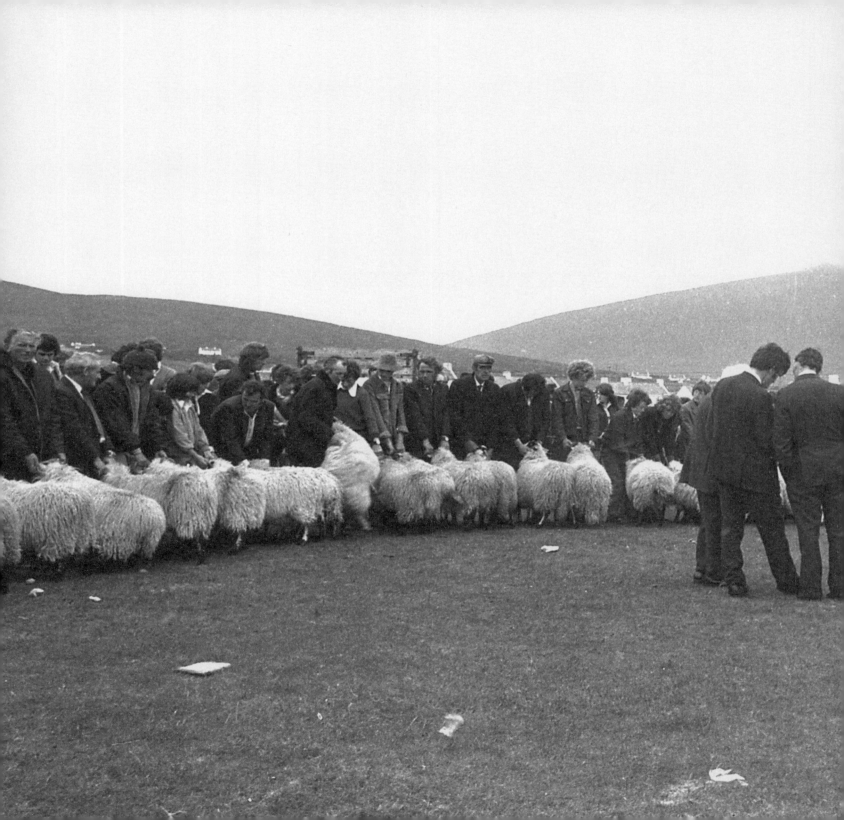

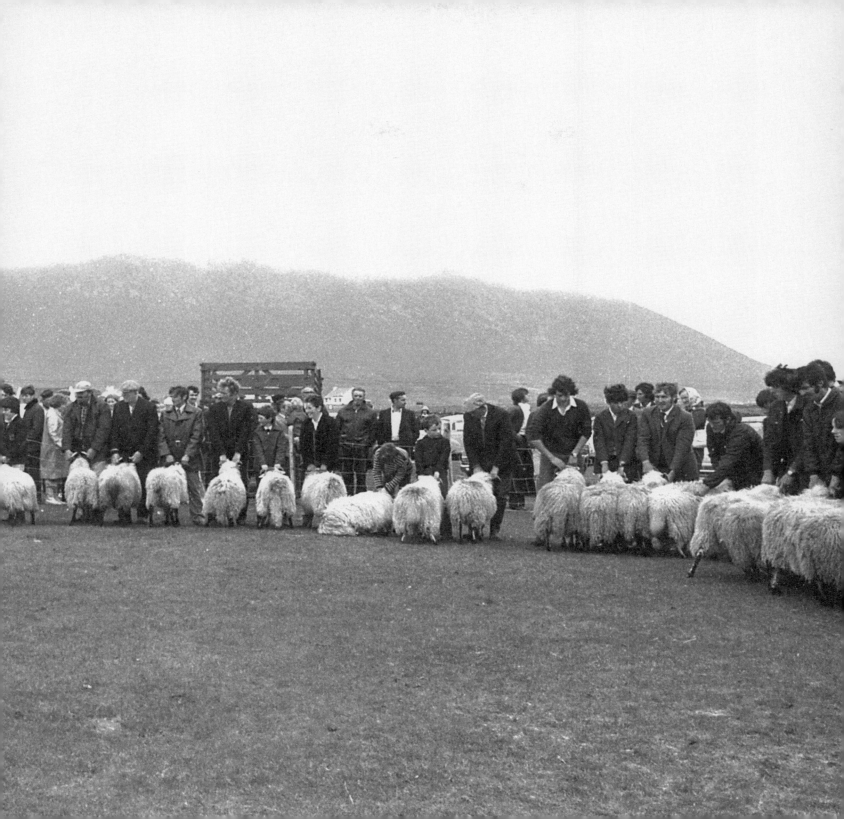

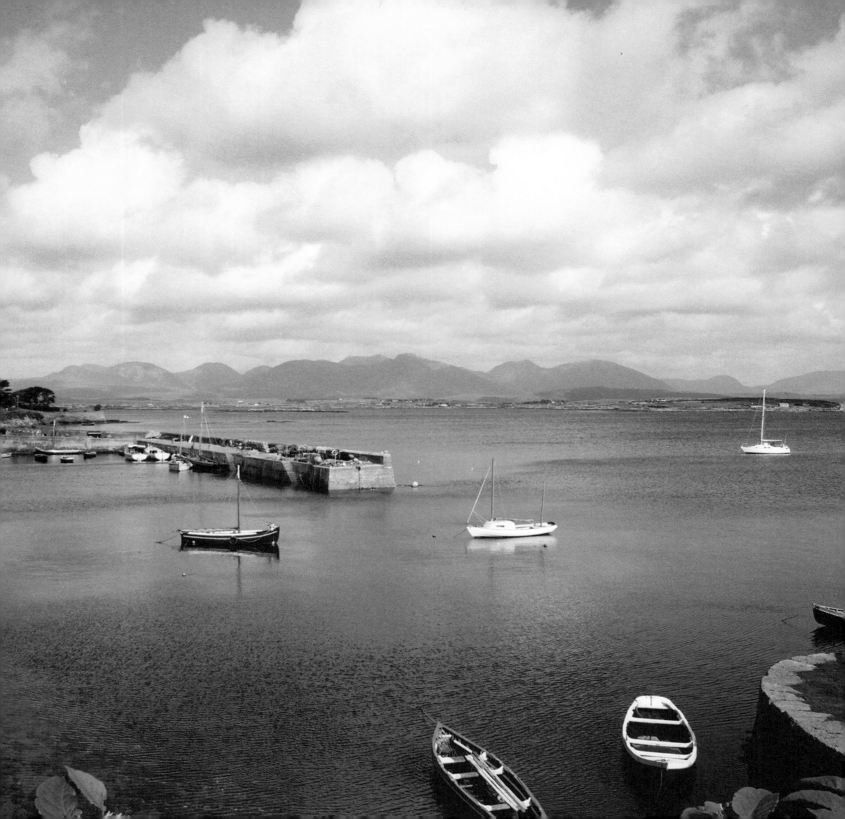

Best Loved Poems

Favourite Poems from the West of Ireland

EDITED BY THOMAS F. WALSH & PHOTOGRAPHY BY LIAM LYONS

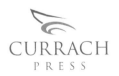

CURRACH PRESS

Previous: Sixth Annual Sheep & Cattle Sale in Achill.

Opposite: Roundstone Harbour.

First published in paperback in 2013 by Currach Press
55A Spruce Avenue
Stillorgan Industrial Park
Blackrock
Co. Dublin
Ireland

British Library Cataloguing in Publication Data
An entry can be found on request

ISBN: 978 1 78218 882 7
This hardback edition, 2016

Library of Congress Cataloging–in–Publication Data
An entry can be found on request

Book design by www.sinedesign.net
Printed by L&C Printing Group, Poland

Croagh Patrick, cloud collection.

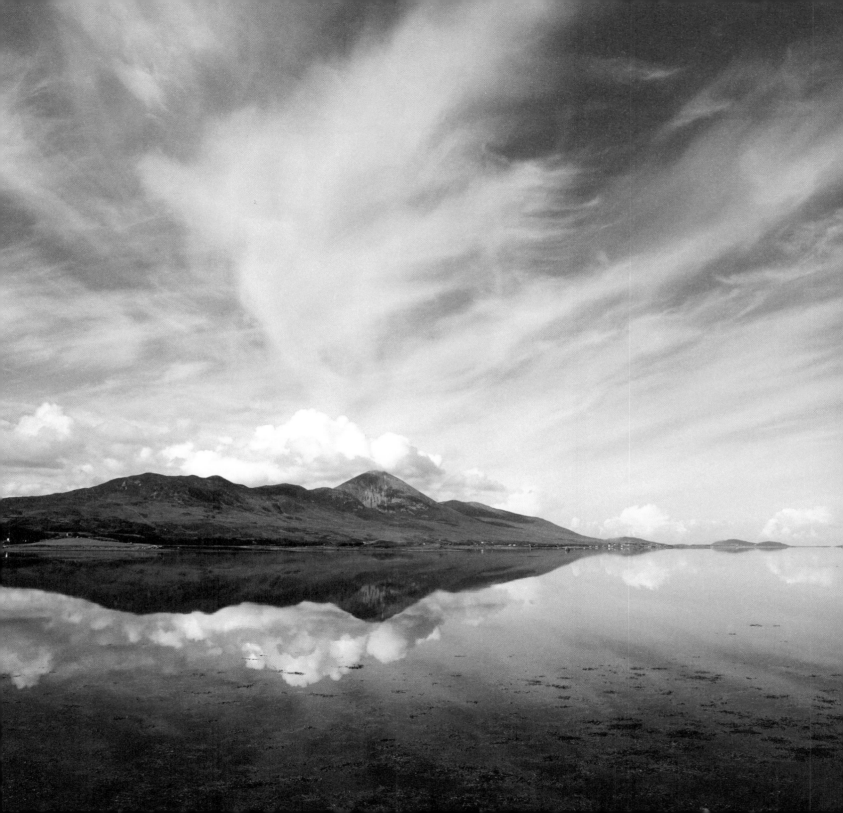

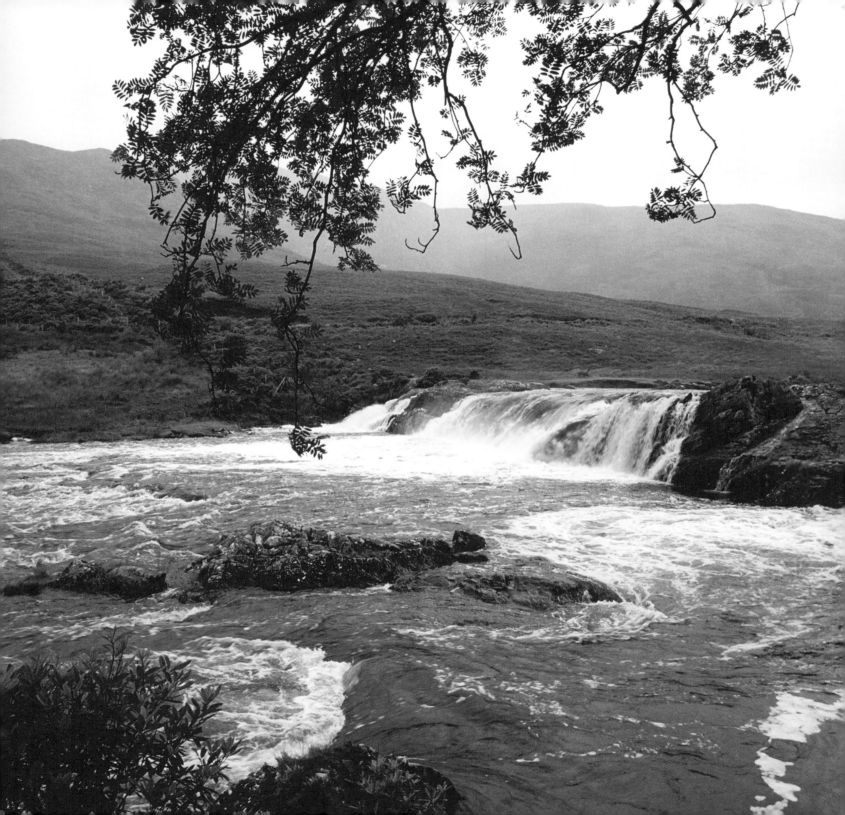

Contents

Ashleigh Falls.

Coumeenoole Strand, Dingle.

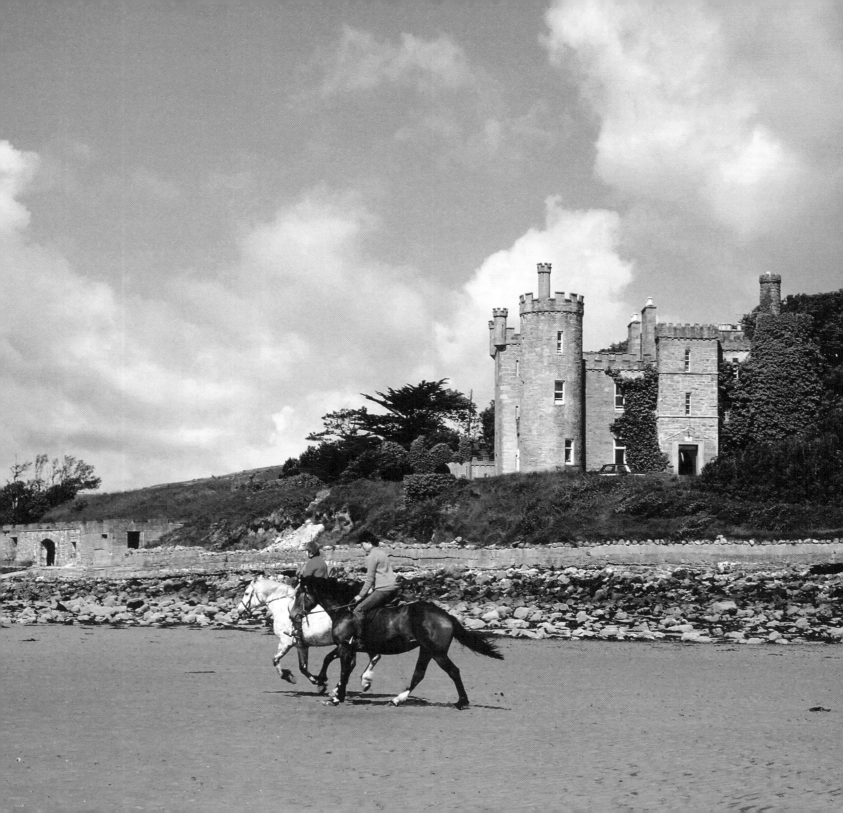

Introduction

The west of Ireland, the old province of Connacht, is, for the most part, a wild and beautiful place. Its rugged coastline breasts the broad Atlantic. Its mountains and glens are often lonely places, but if you look closely against a slanting evening sun you might see the traces of some old cultivation 'where mountainy men have sown' as Pádraig Pearse observed. And those of us who grew up there remember how it used to be when the fields were tilled and the turf was saved.

I know only too well from *Favourite Poems We Learned in School* that poetry is a great vehicle of memory. Lines lodged in the heart can conjure up better than any other medium, I think, scenes from our childhood. And if we were lucky enough to be born in that magical place we will cherish those lines and, remembering them, we will recall, too, the people who lived there and the lives they lived.

All collections of poetry are, of course, subjective. The poems I have selected here are, generally, poems from our younger days. They are well known. You will remember them. They will bring you back. There is nothing wrong with being sentimental about people and places we loved. The west of Ireland suffered the scourge of the Great Famine more than any other province and consequently emigration has played its tragic part in its history. The poems and pictures from this collection will, I'm sure, be cherished by people from the west no matter where they have settled in this great world.

There are, of course, poems that recount our history. We are nothing without our history.

For the most part, then, these are the poems of our childhood, the kind of poems we learned in school but have half forgotten. Some are in our native Irish tongue. The poets are, for the most part, native to Connacht, but forgive me please if their connection with the west seems at times tenuous. Pearse spent long enough in Rosmuc for us to claim him as one of our own. Pádraic Colum was born near enough to the Shannon stream and Emily Lawless spent most of her youth in Castlehackett, County Galway. The biographical notes on page 3 will reveal all!

The photographs, like the poems and the place itself, have a haunting quality about them. I was indeed blessed to discover the unique talent of Liam Lyons, the internationally acclaimed photographer from Westport. I know you will relish his imaginative interpretation of the people and landscape of the western islands of Boffin, Shark and Turk and all that wild coastline that shoulders the broad Atlantic. I cannot imagine a better accompaniment to the poems. I feel sure you will enjoy them both.

Thomas F. Walsh

Rosturk Castle.

Thomas F. Walsh, compiler of the very successful *Favourite Poems We Learned in School* series, published by Mercier Press, was born in Headford, County Galway. He is also the author of a biography entitled *Once in a Green Summer,* also published by Mercier, and a collection of short reflections entitled *In Silent Moments,* published by Currach Press. He has been a regular contributor to *Sunday Miscellany* and *Quiet Quarter* on radio. He is a retired primary school headmaster and now lives in Westport, County Mayo.

A Note from the Photographer

When Tom Walsh first approached me with a proposal to provide a selection of photographs to relate to his collection of poems, I felt both challenged and very honoured to be asked to do this. For me, these poems had many memories from my school days.

This request was timely as Carmel Kiernan, archivist from the Mayo County Library, and I, were deep into many thousands of negatives from more than fifty years of my life's work. I was privileged to have a very wide variety of work in my commissions and also to live in Westport with its wonderful landscapes and seascapes all around me.

The addition of Carmel to the project brought professional skills to a daunting job. She developed a deep personal interest in the collection. Her use of digital technology has made the file search faster. Also, I would like to pay tribute to my very patient wife Mabel, who insisted from the outset to properly file and date all negatives. At this time the work continues so that future generations, including students, writers and researchers, can access the history of past generations.

Once again I wish to thank the Mayo County Council and Carmel Kiernan as without their help this work would not have been possible. I thank them for their foresight and particularly the then County Manager, Des Mahon, and the current County Manager, Peter Hynes. As I have already said, without their help, this project could not have been achieved in my lifetime.

Liam Lyons

Professional photographer **Liam Lyons** lives on the shores of Clew Bay, where Croagh Patrick, Ireland's holy mountain, comes and goes, forms and dissolves constantly in the sun and cloud. His surroundings have been a source of constant inspiration throughout his career. Now retired, Liam was the first Irish photographer to have been awarded an honourary Fellowship for Landscape photography from the Irish Professional Photographers Association. His work hangs in many homes around the world including the White House and the state residence of the Irish President. Currently, Liam is working with Mayo County Library archiving fifty years of his photographic career.

www.liamlyons.com

Biographical Notes

William Allingham (1824 – 1889) was born in Ballyshannon, County Donegal. He worked as a customs officer in Ulster before settling in England. He became editor of *Fraser's Magazine* and was a friend of Carlyle and Tennyson. Most of his poems are about his native Donegal.

William A. Byrne (1876 – 1933) was born in Kildare, and was educated at Knockbeg College, County Carlow, at Maynooth, and at London University. For the last sixteen years of his life he occupied the chair of English at University College, Galway. He published only one book of poetry, *The Light on the Broom*.

John Keegan Casey (1846 – 1870) was born near Mullingar, the son of a teacher. He taught school himself and later worked as a clerk until his arrest as a Fenian in 1867. He contracted tuberculosis in prison and never fully recovered. He was a regular contributor to *The Nation* and his famous ballad 'The Rising of the Moon' was written when he was only fifteen. His funeral was attended, it is said, by 50,000 people, a tribute to both his politics and his verse.

Pádraic Colum (1881 – 1972) was born in County Longford and wrote plays and novels as well as poetry. He was an associate of Yeats, Synge and Lady Gregory and was one of the first playwrights of the Abbey Theatre. He emigrated to America in 1914 and spent most of his life there. He is chiefly remembered for his enduring lyrics of Irish rural life such as 'The Old Woman of the Roads', 'Cradle Song' and 'She Moved through the Fair'.

Thomas Davis (1814 – 1845) was born in Mallow and educated at Trinity College. He was called to the Bar, but chose to become a journalist and to devote his pen to the cause of Irish nationhood. In 1842, with Charles Gavan Duffy and John Blake Dillon he founded *The Nation,* to which he contributed both prose and poetry. He died of scarlet fever at the age of thirty-one.

Monsignor Pádraig De Brún (1889 – 1960) was born in County Tipperary and was ordained to the priesthood at Clonliffe College in 1913. He attended University College Dublin and was a professor at Maynooth College for many years. In 1945 he was appointed President of University College Galway. He is well known

for his translations from the classics of Sophocles and Homer into Irish. He is an uncle of the well-known Irish poet, Máire Mhac an tSaoi.

Dubhghlas de hÍde (1860 – 1949), Gaelic scholar and first President of Ireland, was born in Frenchpark, County Roscommon. He became Professor of Modern Irish at the National University. He was a prolific writer and translator and was the driving force of the Irish Literary Revival. He was proficient in Latin, Greek, Hebrew, German and French but Irish was his first love. He was one of the founders of The Gaelic League (*Conradh na Gaeilge*). He wrote many plays and poems in Irish and English.

Paul Durcan (b. 1944) was born in Dublin and educated at Gonzaga College and University College Cork. One of Ireland's best known and most widely enjoyed poets, he won the Whitbread Poetry Prize in 1990 for his collection *Daddy, Daddy*. His work is often satirical and marked by a deep-felt social consciousness.

Francis A. Fahy (1854 – 1935) was born in Kinvara, County Galway and joined the English civil service in London in 1876. He became President of the London Gaelic League and founder of the Irish Literary Society. He wrote many famous songs and ballads such as 'The Oul' Plaid Shawl' and 'The Queen of Connemara' which first appeared in *Irish Songs and Poems* (1887).

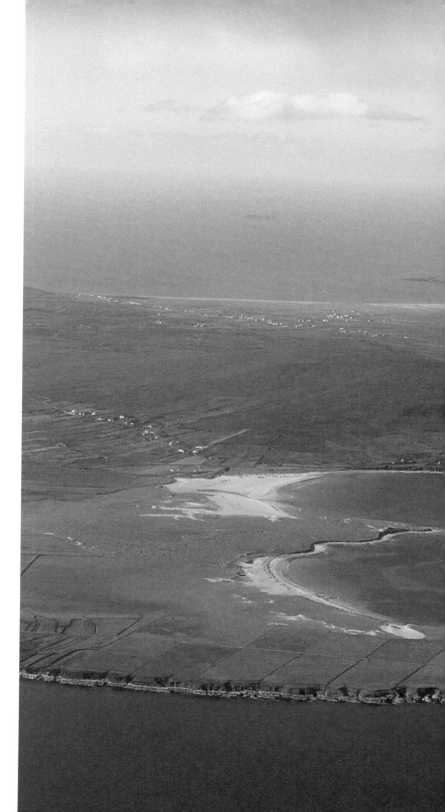

Aerial view of Dugort, Achill.

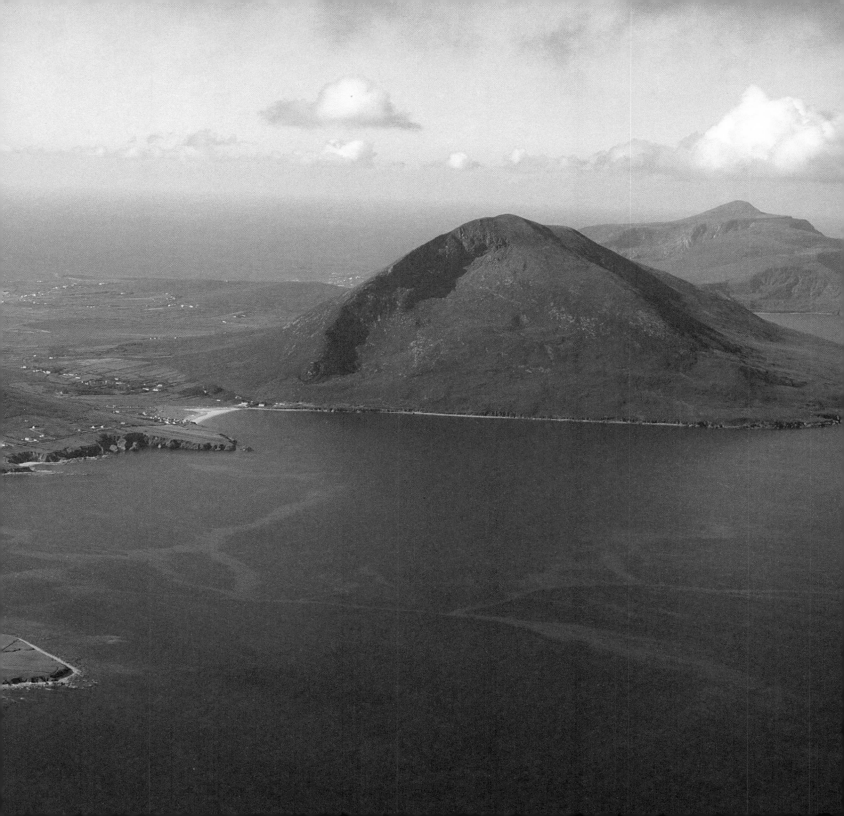

Padraic Fallon (1906 – 1974) was born in Athenry, County Galway and educated in Roscrea. He joined the Customs and Excise Department and was appointed to Wexford in 1939 where he lived until retirement in 1970. Many of his radio plays, based on Irish sagas, were broadcast in the 1950s.

George Fox (b. 1809 – ?1880) was born in Belfast and graduated from Trinity College, Dublin, before emigrating to America. Little else is known about him. The Irish poem by Thomas Lavelle, of which 'The County of Mayo' is a translation, originated in the seventeenth or early eighteenth century and was written to a beautiful old melody familiar to the people of Mayo and Galway.

Percy French (1854 – 1920) was born in Cloonyquin, County Roscommon, and, after graduating from Trinity College, Dublin, became 'inspector of drains' in County Cavan. Even from an early age he had begun to write the many comic songs for which he is famous, such as 'The Mountains of Mourne' and 'Come Back Paddy Reilly'. When his work finished in 1887 he began touring as a performer of his own material: songs, monologues and sketches. He was also a talented artist.

Oliver Goldsmith (1730 – 1774) was probably born at Elphin, County Roscommon, although this is disputed. He studied medicine but did not practise. Instead he became a teacher and writer in London and became an associate of Samuel Johnson, Edmund Burke and Joshua Reynolds. His most famous works are the novel *The Vicar of Wakefield,* the play *She Stoops to Conquer* and the poem 'The Deserted Village'.

Gerald Griffin (1803 – 1840) was born in Limerick. He went to London at an early age with hopes of becoming a successful dramatist, but although he wrote some poetry and a novel entitled *The Collegians,* he became disillusioned and burned all his manuscripts. He joined the Order of the Christian Brothers and died two years later.

F. R. Higgins (1896 – 1941). Frederick Robert Higgins was born in Foxford, County Mayo, and reared in Dublin. He was strongly influenced by the Irish Literary Revival and became a close friend of Yeats and Austin Clarke. His poetry was influenced by the Connacht people he admired. He later became business manager and director of the Abbey Theatre. He published five collections of poetry, notably *The Dark Breed* (1927) and *The Gap of Brightness* (1941).

William Larminie (1849 – 1900) was born in Castlebar, County Mayo and educated at Trinity College, Dublin. After his graduation he joined the civil service in London. He was particularly interested in folklore collected in Connacht and

Donegal. He published *Fand and Other Poems* (1892) and *West Irish Folk-Tales and Romances* (1893).

Emily Lawless (1845 – 1913), daughter of Lord Cloncurry, was born in County Kildare but spent most of her youth in Castlehackett, County Galway, home of the Kirwans, her mother's people. She drew on west of Ireland themes for many of her works. Her chief novels are *Hurrish* (1886) and *With Essex in Ireland* (1890), but she is best remembered for her verse collection *With the Wild Geese* (1902). She spent her later years in England.

Seán Lysaght was born in 1957 and grew up in Limerick. He now lives in Westport and lectures at the Galway-Mayo Institute of Technology. His publications include *Robert Lloyd Praeger: The Life of a Naturalist* and *Venetian Epigrams,* translations from Goethe (Gallery, 2008), and five collections of poems, most recently *The Mouth of a River* (Gallery, 2007). He received the 2007 O'Shaughnessy Award for Poetry.

Derek Mahon (b. 1941) was born in Belfast and studied Classics at Trinity College, Dublin. He worked as a teacher and journalist and was writer in residence at TCD. He has published many collections of poetry, including *The Hunt by Night* (1982), *The Hudson Letter* (1996) and *The Yellow Book* (1997). John Banville has described his poem 'A Disused Shed in County Wexford' as 'the most beautiful single poem produced by an Irishman since the death of Yeats'.

James Clarence Mangan (1803 – 1849) was born in Dublin, the son of a grocer who fell on hard times. He received his education from a Fr Graham and found occasional work in the library in TCD and later with the Ordnance Survey Office. He became addicted to opium and alcohol. Many of his poems such as 'Dark Rosaleen' were translations from the Irish and he was a contributor to *The Nation*. He is now regarded as one of the most significant Irish poets of the mid-nineteenth century.

Richard Murphy (b. 1927) was born in Milford House, his family home in County Galway. His boyhood was spent in Ceylon and the Bahamas where his father worked in the British Colonial Service. He ran a school in Crete before coming to live in Inishboffin off the Connemara coast which is the inspiration for much of his poetry, including his collection *Sailing to an Island* (1963). *The Battle of Aughrim* (1968) contains a commentary on the aftermath of the Williamite wars.

Máirtín Ó Direáin (1910 – 1988), poet in Irish, was born in Inis Mór in the Aran Islands. He worked in the post office in Galway and later in the civil service in Dublin. His collection *Rogha Dánta* (1949) established his reputation as a major poet. His verse celebrates the natural beauty of his native Aran Islands and contrasts it to the bleakness of modern city life.

Antaine Ó Reachtaire (?1784 – 1835) is one of the most remarkable of Irish poets. Born near Kiltimagh in County Mayo, he was blinded by smallpox at the age of nine and had to spend most of his life as a beggar, playing the violin and composing poems on local people and events. He spent much of his life in the Gort, south Galway area as well as Mayo. 'Cill Aodáin', a celebration of spring is one of the best known poems in modern Irish and 'Eanach Dhúin', his lament for the drowned in the Corrib tragedy of 1822 is remarkable for its power and cadence. His most famous poem, 'Mise Raifteirí' was probably not his own composition.

Eoghan Ó Tuairisc (aka Eugene Watters) (1919 – 1982) was born in Ballinasloe, County Galway, educated at Garbally and served as an officer in the army. After the war he trained as a teacher at St Patrick's College, Drumcondra and taught in Dublin until 1961 when he became a full-time writer, travelling the country in a horse-drawn caravan with his wife, the artist, Una McDonnell. His first novel, *L'Attaque* (1962) was set in County Mayo during the Rising of 1798.

Pádraig H. Pearse (1879 – 1916) was born in Dublin but spent much of his youth in Rosmuc, Connemara, where he learned Irish and wrote poems, stories and plays in both Irish and English. He founded St Enda's School in Rathfarnham and edited *An Claidheamh Soluis,* the weekly journal of the Gaelic League. He played a prominent part in the formation of the Irish Volunteers and was executed for his part in the Easter Rising of 1916. *The Wayfarer* was written on the day before his death.

T. W. Rolleston (1857 – 1920) was born in Shinrone, County Offaly and educated at Trinity College, Dublin and in Germany. He was founding editor of the *Dublin University Review* and secretary of the Irish Literary Society in London. He was an authority on German literature and became German editor for the *Times Literary Supplement.* His poetry is contained in *Sea Spray: Verses and Translations* (1909) and his prose works include *Myths and Legends of the Celtic Race* (1911).

J. M. Synge (1871 – 1909), dramatist and poet, was born near Dublin and was of Anglo-Irish background. He was educated at Trinity College, Dublin and spent some years in Paris, where he met W. B. Yeats. On Yeats' suggestion he spent some time in the Aran Islands in order to write about Irish peasant life in Hiberno-English. Among his most famous plays are *Riders to the Sea* and *The Playboy of the Western World*.

Katharine Tynan (1861 – 1931) was born on her father's farm in Clondalkin, County Dublin but spent some of her later years in Mayo where her husband, Henry Albert Hinkson, was Resident Magistrate. She was an ardent nationalist and a friend of Yeats. A prolific writer, she wrote 105 novels, twelve collections of short stories and eighteen collections of verse.

William Butler Yeats (1865 – 1939) was born in Dublin but spent much of his childhood with his mother's family, the Pollexfens. In Dublin he came to know John O'Leary, the Fenian, as well as Maud Gonne, the nationalist who was to obsess him romantically for much of his life. He was associated with the Irish Literary Revival and the foundation of the Abbey Theatre. He was supported financially by Lady Gregory and spent many happy times in Coole Park, near Gort, County Galway. Such poetry collections as *The Wild Swans at Coole* (1919) gained him worldwide recognition and he won the Nobel Prize in 1923. He was elected an Irish senator in the new government. He is buried in Drumcliffe, County Sligo.

Ella Young (1867 – 1956), born in Fenagh, County Antrim, was active in the Irish Literary Revival and wrote children's books as well as poetry. She was a friend of Pearse and a member of Cumann na mBan and played a part in the Easter Rising. She emigrated to the United States in 1925 and held the chair of Irish Myth and Lore for seven years at the University of California, Berkeley. Her first anthology, entitled simply *Poems,* was published in 1906 and Maud Gonne illustrated her first book of stories, *Celtic Wonder Tales* in 1910.

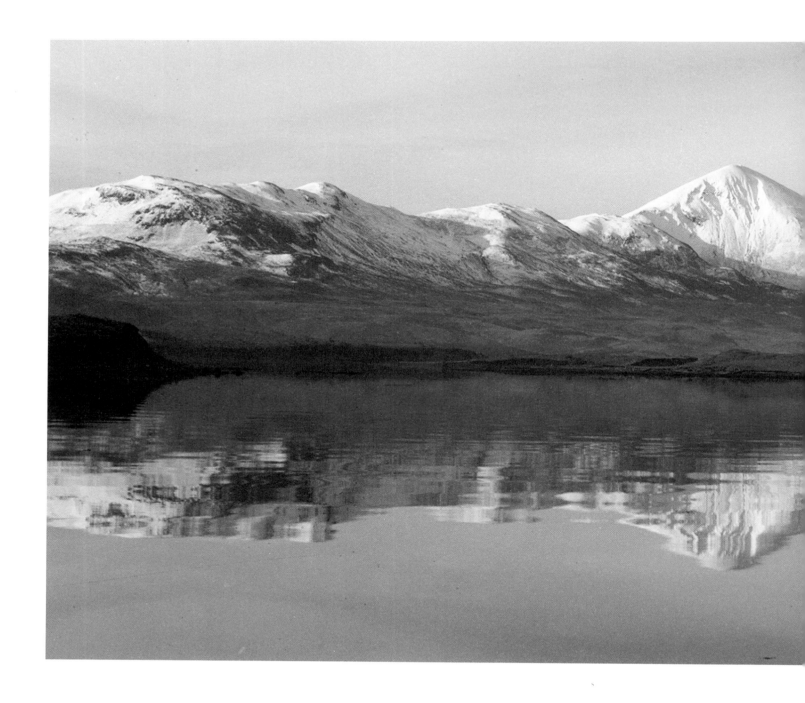

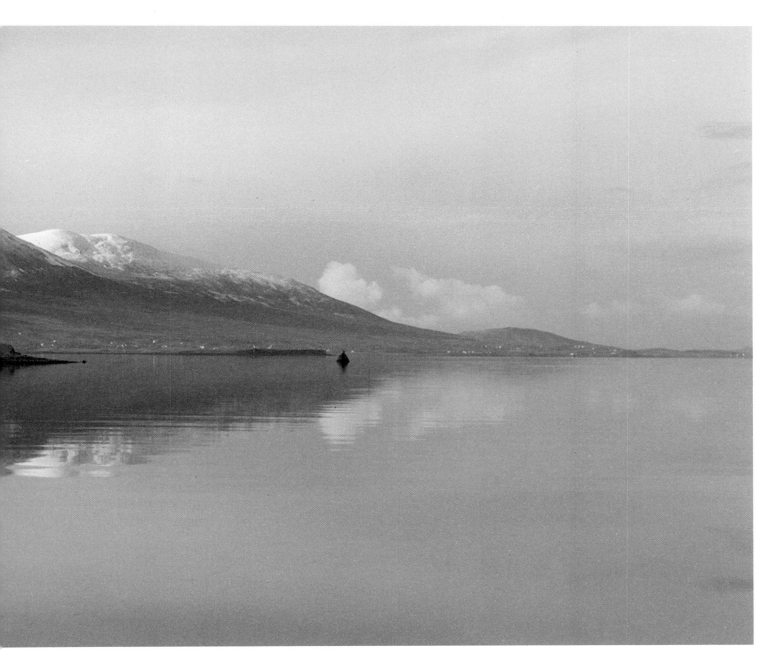

Croagh Patrick.

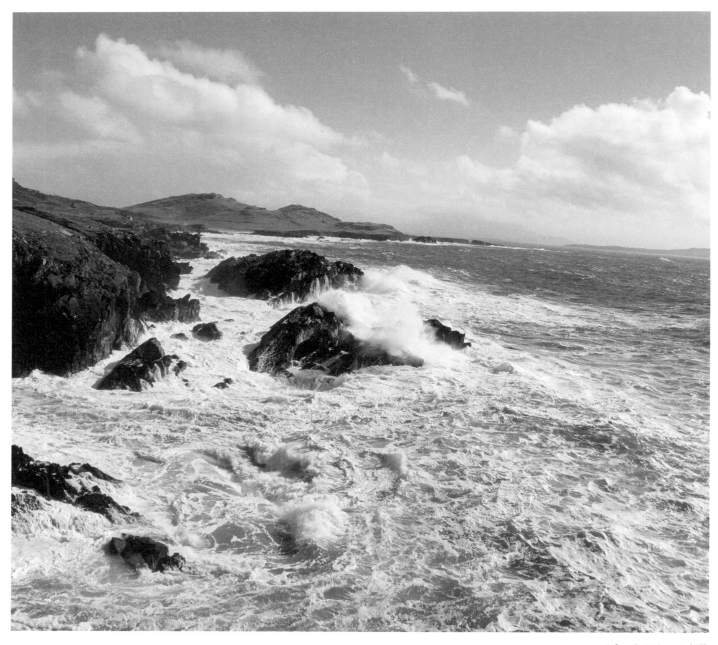

Atlantic Drive, Achill.

The Wind From The West

Blow high, blow low,
 O wind from the west,
You come from the country
 I love the best.

O say have the lilies
 Yet lifted their heads
Above the lake water
 That ripples and spreads?

Do the little sedges
 Still shake with delight,
And whisper together
 All through the night?

Have the mountains the purple
 I used to love,
And peace about them,
 Around and above?

O wind from the west,
 Blow high, blow low,
You come from the country
 I loved long ago.

Ella Young (1867 – 1956)

The Old Woman of the Roads

Oh to have a little house!
To own the hearth and stool and all,
The heaped-up sods upon the fire,
The pile of turf against the wall!

To have a clock with weights and chains,
And pendulum swinging up and down!
A dresser filled with shining delph,
Speckled and white and blue and brown!

I could be busy all the day,
Cleaning and sweeping hearth and floor,
And fixing on their shelves again
My white and blue and speckled store!

I could be quiet there at night
Beside the fire and by myself,
Sure of a bed and loath to leave
The ticking clock and the shining delph!

Och! But I'm weary of mist and dark,
And roads where there's never a house nor bush,
And tired I am of bog and road,
And the crying wind and the lonesome hush!

And I am praying to God on high,
And I am praying Him night and day,
For a little house – a house of my own –
Out of the wind and the rain's way.

Pádraic Colum (1881 – 1972)

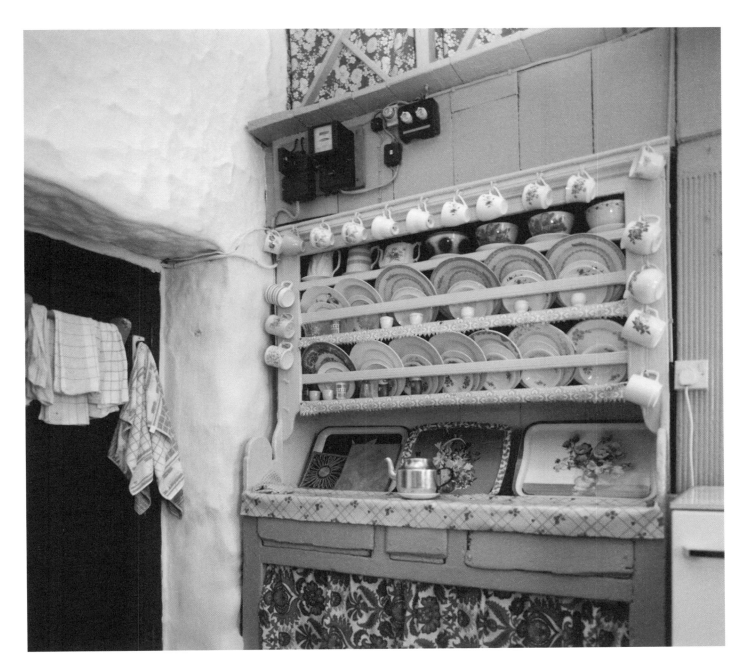

Brid's Dresser.

The Bog Lands

The purple heather is the cloak
God gave the bogland brown,
But man has made a pall of smoke
To hide the distant town.

Our lights are long and rich in change,
Unscreened by hill or spire,
From primrose dawn, a lovely range,
To sunset's farewell fire.

No morning bells have we to wake
Us with their monotone,
But windy calls of quail and crake
Unto our beds are blown.

The lark's wild flourish summons us
To work before the sun;
At eve the heart's lone Angelus
Blesses our labour done.

We cleave the sodden, shelving bank,
In sunshine and in rain,
That men by winter fires may thank
The wielders of the slane.

Our lot is laid beyond the crime
That sullies idle hands;
So hear we through the silent time
God speaking sweet commands.

Brave joys we have and calm delight—
For which tired wealth may sigh—
The freedom of the fields of light,
The gladness of the sky.

And we have music, oh, so quaint,
The curlew and the plover,
To tease the mind with pipings faint
No memory can recover;

The reeds that pine about the pools
In wind and windless weather;
The bees that have no singing-rules
Except to buzz together.

And prayer is here to give us sight
To see the purest ends;
Each evening through the brown-turf light
The Rosary ascends.

And all night long the cricket sings
The drowsy minutes fall,—
The only pendulum that swings
Across the crannied wall.

Then we have rest, so sweet, so good,
The quiet rest you crave;
The long, deep bogland solitude
That fits a forest's grave;

The long, strange stillness, wide and deep,
Beneath God's loving hand,
Where, wondering at the grace of sleep,
The Guardian Angels stand.

William A. Byrne (1876 – 1933)

The Lake Isle of Innisfree

I will arise and go now, and go to Innisfree,
And a small cabin build there, of clay and wattles made:
Nine bean-rows will I have there, a hive for the honey-bee
And live alone in the bee-loud glade.

And I shall have some peace there, for peace comes dropping slow,
Dropping from the vales of the morning to where the cricket sings;
There midnight's all a-glimmer, and noon a purple glow,
And evening full of the linnet's wings.

I will arise and go now, for always night and day
I hear lake water lapping with low sounds by the shore;
While I stand on the roadway or on the pavements grey,
I hear it in the deep heart's core.

William Butler Yeats (1865 – 1939)

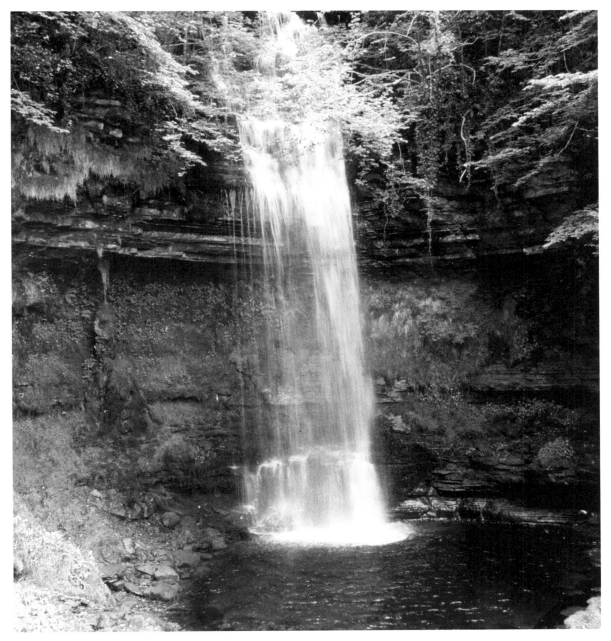

Glencar lake.

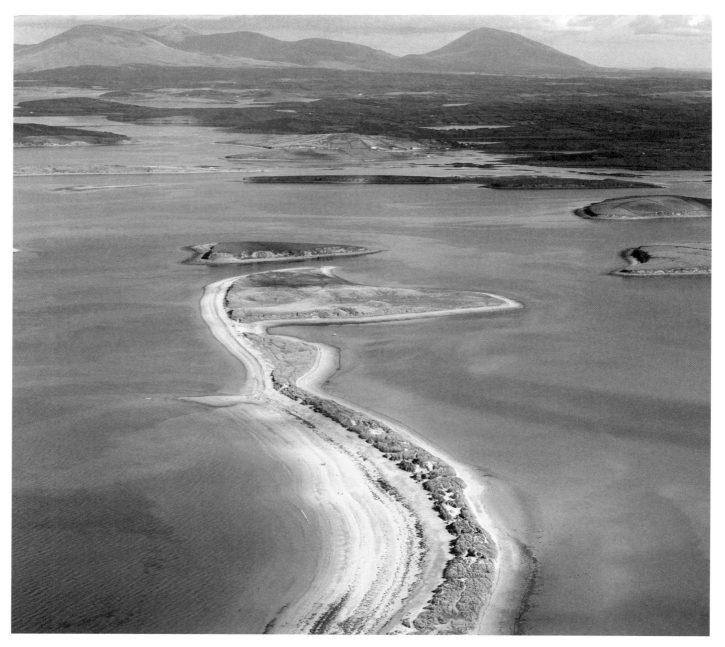

Bertra Beach, Clew Bay.

Hy-Brasail – the Isle of the Blest

On the ocean that hollows the rocks where ye dwell,
A shadowy land has appeared as they tell;
Men thought it a region of sunshine and rest,
And they called it Hy-Brasail, the isle of the blest.
From year unto year, on the ocean's blue rim,
The beautiful spectre showed lovely and dim;
The golden clouds curtained the deep where it lay
And it looked like an Eden, away, far away!

A peasant, who heard of the wonderful tale,
In the breeze of the Orient loosened his sail;
From Ara, the holy, he turned to the west,
For though Ara was holy, Hy-Brasail was blest.
He heard not the voices that called from the shore—
He heard not the rising wind's menacing roar:
Home, kindred and safety he left on that day,
And he sped to Hy-Brasail, away, far away!

Morn rose on the deep, and that shadowy isle
O'er the faint rim of distance reflected its smile;
Noon burned on the wave, and that shadowy shore
Seemed lovelily distant, and faint as before;
Lone evening came down on the wanderer's track,
And to Ara again he looked timidly back;
Oh, far on the verge of the ocean it lay,
Yet the isle of the blest was away, far away!

Rash dreamer, return! O ye winds of the main,
Bear him back to his own peaceful Ara again!
Rash fool! for a vision of fanciful bliss,
To barter the calm life of labour and peace.
The warning of reason was spoken in vain;

He never revisited Ara again!
Night fell on the deep, amidst tempest and spray,
And he died on the waters, away, far away!

To you, gentle friends, need I pause to reveal
The lessons of prudence my verses conceal;
How the phantom of pleasure seen distant in youth,
Oft lures a weak heart from the circle of truth.
All lovely it seems, like a shadowy isle,
And the eye of the wisest is caught by its smile;
But ah! For the heart it has tempted to stray
From the sweet home of duty, away, far away!
Poor friendless adventurer! Vainly might he
Look back to green Ara along the wild sea;
But the wanderer's heart has a guardian above,
Who, though erring, remembers the child of His love.
Oh, who at the proffer of safety would spurn,
When all that he asks is the will to return;
To follow a phantom, from day unto day,
And die in the tempest, away, far away!

Gerald Griffin (1803 – 1840)

Cill Aodáin

Anois teacht an earraigh beidh and lá 'dul 'un síneadh,
'S tar éis na Féil Bríde ardóidh mé mo sheol;
Ó chuir mé 'mo cheann é ní chónóidh mé choíche
Go seasfaidh mé síos i lár Chontae Mhaigh Eo.
I gClár Chlainne Mhuiris a bheas mé an chéad oíche,
'S i mBalla taobh thíos de thosós mé ag ól;
Go Coillte Mach rachad go ndéanad cuairt mhíosa ann,
I bhfogas dhá mhíle do Bhéal an Áth' Móir.

Ó fágaim le huacht é go n-éiríonn mo chroíse,
Mar éiríos an ghaoth nó mar scaipeas an ceo,
Nuair smaoiním ar Cheara nó ar Ghaileang taobh thíos de,
Ar Sceathach a' Mhíle 's ar phlánaí Mhaigh Eo;
Cill Aodáin an baile a bhfásann gach ní ann –
Tá sméara 's sú chraobh ann is meas ar gach sórt;
'S dá mbéinnse 'mo sheasamh i gceartlár mo dhaoine,
D'imeodh an aois díom is bheinn arís óg.

Antaine Ó Reachtaire (?1784 – 1835)

Galway Bay

'Tis far away I am today from scenes I roamed, a boy;
And long ago the hour I know I first saw Illinois.
No time nor tide nor waters wide could wean my heart away,
Forever true, I'll fly to you, my own dear Galway Bay.

My chosen bride is at my side, her brown hair turning grey;
Her daughter Rose more like her grows, from April dawn 'till May.
Our only boy, his mother's joy, his father's pride today,
With scenes like these I'd live at ease beside you Galway Bay.

Oh, grey and bleak, by shore and creek, the rugged rocks abound,
But sweet and green the grass between as grows on Irish ground;
Saw friendships found and wealth abound and a love that lives always;
Bless every home beside your foam, my own dear Galway Bay.

Had I youth's blood and hopeful mood and a heart of fire once more,
For all the gold this world might hold, I'd never leave your shore;
I'd be content with whate'er God sent, with neighbours old and grey,
And I'd lay my bones 'neath churchyard stones, beside you Galway Bay.

The blessings of a poor old man be with you night and day,
The blessings of a lonely man whose heart will soon be clay;
It's all of heaven I'll ask of God upon my dying day –
Is my soul to soar forever more above you, Galway Bay.

Francis A. Fahy (1854 – 1935)

Going Home to Mayo, Winter, 1949

Leaving behind us the alien, foreign city of Dublin
My father drove through the night in an old Ford Anglia,
His five-year-old son in the seat beside him,
The rexine seat of red leatherette,
And a yellow moon peeped in through the windscreen.
'Daddy, Daddy,' I cried, 'Pass out the moon,'
But no matter how hard he drove he could not pass out the moon.
Each town we passed through was another milestone
And their names were magic passwords into eternity:
Kilcock, Kinnegad, Strokestown, Elphin,
Tarmonbarry, Tulsk, Ballaghadereen, Ballavarry;
Now we were in Mayo and the next stop was Turlough,
The village of Turlough in the heartland of Mayo,
And my father's mother's house, all oil-lamps and women,
And my bedroom over the public bar below,
And in the morning cattle-cries and cock-crows:
Life's seemingly seamless garment gorgeously rent
By their screeches and bellowings. And in the evenings
I walked with my father in the high grass down by the river
Talking with him – an unheard-of thing in the city.

But home was not home and the moon could be no more outflanked
Than the daylight nightmare of Dublin city:
Back down along the canal we chugged into the city
And each lock-gate tolled our mutual doom;
And railings and palings and asphalt and traffic lights,
And blocks after blocks of so-called 'new' tenements –
Thousands of crosses of loneliness planted
In the narrowing grave of the life of the father;
In the wide, wide cemetery of the boy's childhood.

Paul Durcan (b. 1944)

24

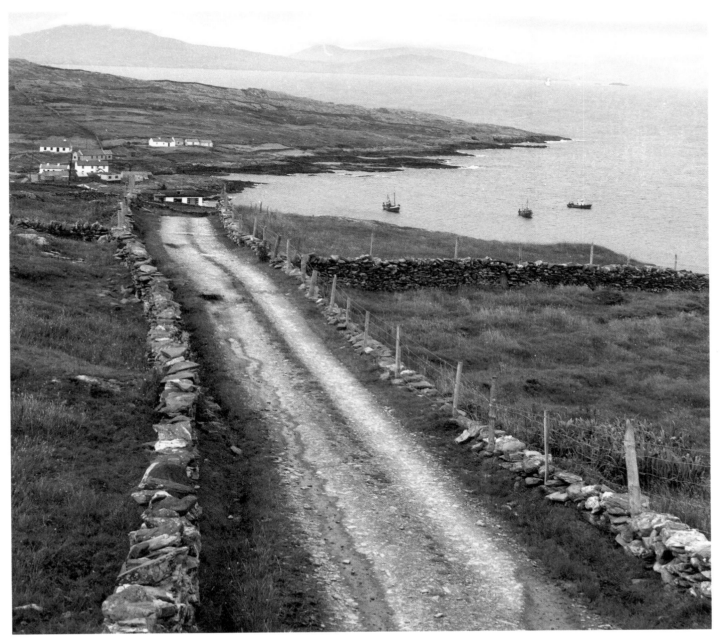

Inishturk.

Eanach Dhúin

Má fhaighimse sláinte, is fada bheas tráchtadh
Ar an méid a bádh as Eanach Dhúin;
'Sé mo thrua amárach gach athair 's máthair,
Bean is páiste 'tá ag sileadh súl.
A Rí na nGrása, a cheap Neamh is Parthas,
Nár bheag an tábhacht dúinn beirt nó triúr;
Ach lá chomh breá leis, gan gaoth ná báisteach,
Lá an bháid acu a scuabadh ar siúl!

Nár mhór an t-ionadh os comhair na ndaoine,
A bhfeiscint sínte ar chúl a gcinn,
Screadadh is caoineadh a scanródh daoine,
Gruaig dá cíoradh 's an chreach dá roinn!
Bhí na buachaillí óga ann, tíocht an fhómhair,
Dá síneadh ar chróchar 's á dtabhairt go cill –
'S gurbh é gléas a bpósadh do bhí dhá dtórramh
'S a Dhia na Glóire, nár mhór an feall!

Ansiúd Dé hAoine chluinfeá an caoineadh
Ag teacht gach taobh, agus greadadh bos,
Is a lán thar oíche, trom tuirseach cloíte
Gan ceo le déanamh acu ach a' síneadh corp.
A Dhia 's a Chríost a d'fhulaing íosbairt,
Do cheannaigh go fírinneach an bocht 's an nocht,
Go Párrthas naofa go dtugair soar leat
Gach créatúr díobh dár thit faoin lot.
Baile an Chláir a bhí in aice láimhe,

Níor lig an t-ádh dhóibh a ghabháil aníos;
Bhí an bás chomh láidir nach dtugann cairde
D'aon mhac mháthar dár rugadh riamh.
Mura scéal a cheapadh dhóibh and lá seo a mbáite,
A Rí na nGrása, nár bhocht an ní!
Ach a gcailleadh uile, gan loch ná sáile
Le seanbhád gránna 's iad láimh le tír!

Milleán géar ar an ionad céanna –
Nár lasa réalt' ann 's nár éirí grian,
Do bháigh an meid úd do thriall in éineacht
Go Gaillimh ar aonach go moch Déardaoin!
Na fir a ghléasfadh cliath 'gus céachta,
Do threabhfadh bréanra 's do chraithfeadh síol
'S na mná dá réir sin do dhéanfadh gach aon rud,
Do shníomhfadh bréid agus anairt chaol.

Tolladh cléibhe 'gus loscadh sléibhe
Ar an áit ar éagadar is milleán crua,
'S a liachtaí créatúir a d'fhág sé faonlag
Ag sileadh 's ag éagaoin gach maidin Luain.
Ní díobháil eolais a chuir dá dtreoir iad
'Ach mí-ádh mór ar an gCaisleán Nua;
'Sé críochnú an ámhráin gur bádh mórán,
D'fhág ábhar dóláis ag Eanach Dhúin.

Antaine Ó Reachtaire (?1784 – 1835)

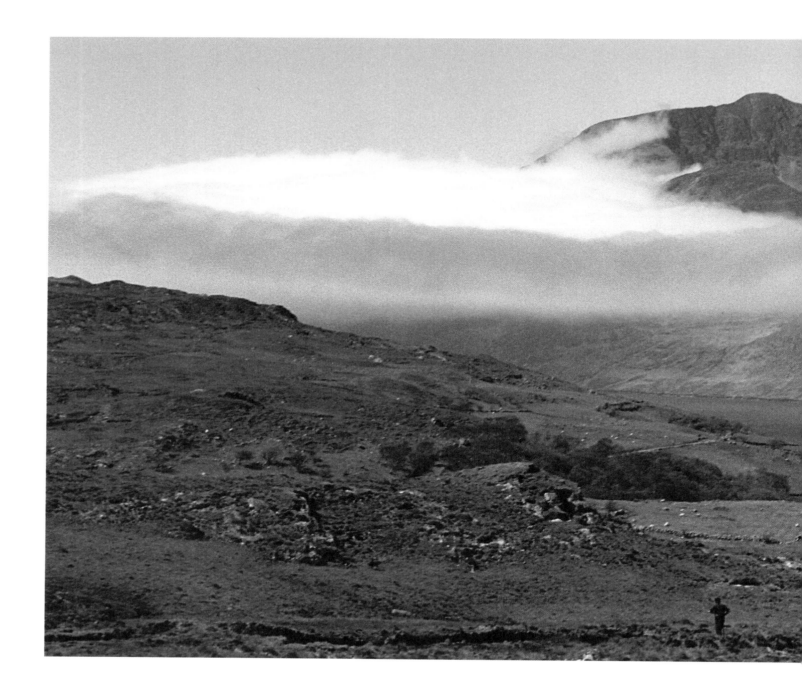

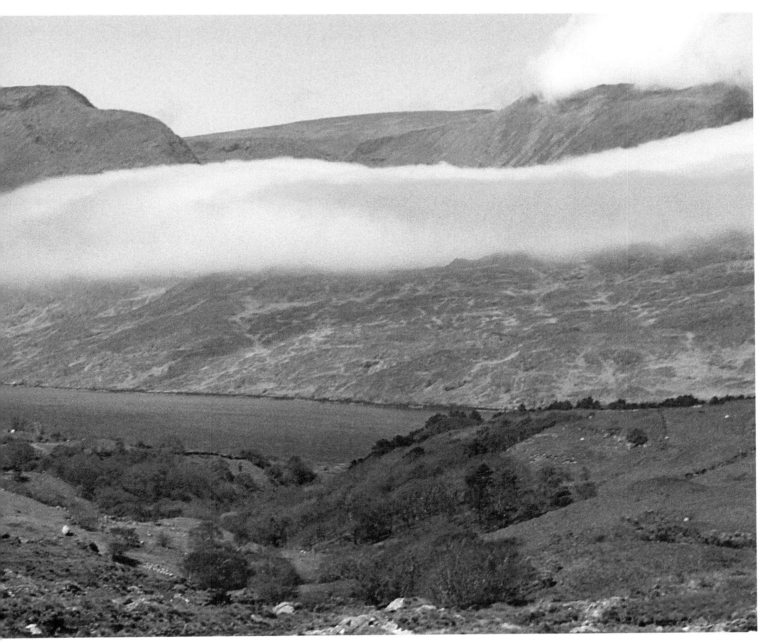

Cloud hangs over Killary fjord and Maol Reidh mountain.

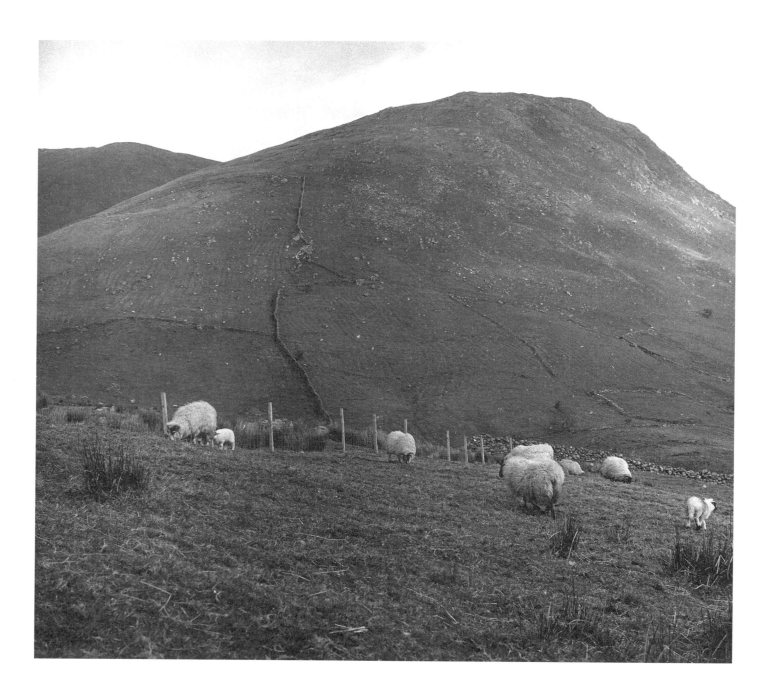

Sheep and Lambs

All in the April evening,
April airs were abroad;
The sheep with their little lambs
Passed me by on the road.

The sheep with their little lambs
Passed me by on the road;
All in the April evening,
I thought on the Lamb of God.

The lambs were weary, and crying
With a weak, human cry.
I thought on the Lamb of God
Going meekly to die.

Up in the blue, blue mountains
Dewy pastures are sweet;
Rest for the little bodies,
Rest for the little feet.

But for the Lamb of God,
Up on the hill-top green,
Only a cross of shame,
Two stark crosses between.

All in the April evening,
April airs were abroad;
I saw the sheep with their lambs,
And thought on the Lamb of God.

Katharine Tynan (1861 – 1931)

She Moved through the Fair

My young love said to me 'my mother won't mind,
And my father won't slight you for your lack of kine,'
And she stepped away from me and this she did say,
'It will not be long, love, till our wedding day.'

She stepped away from me, and moved through the fair,
And sadly I watched her, move here and move there,
Then she went homeward with one star awake –
As the swan in the evening moves over the lake.

The people were saying no two were e'er wed,
But one had a sorrow that never was said,
She went away from me with her goods and her gear,
And that was the last that I saw of my dear.

Last night she came to me, my dear love came in,
So softly she came that her feet made no din,
She laid her hand on me, and this she did say:
'It will not be long, love, till our wedding day.'

Pádraic Colum (1881 – 1972)

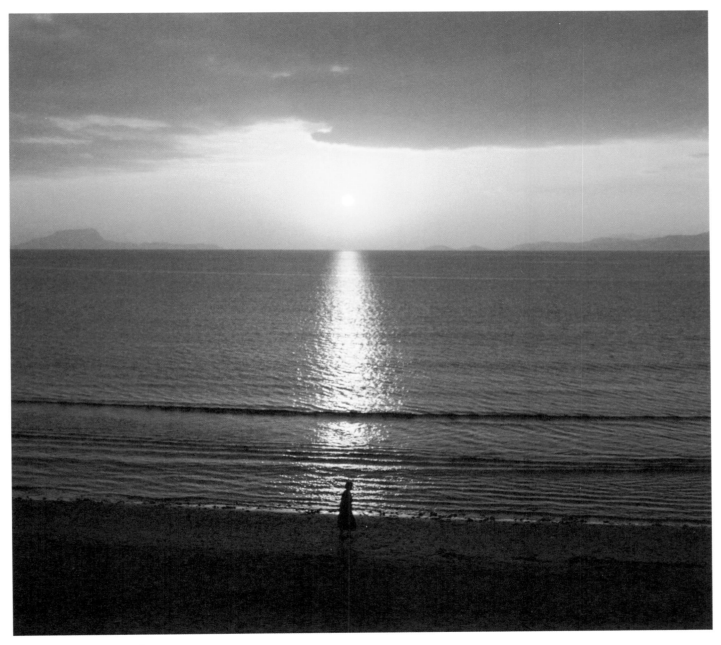

Sunset.

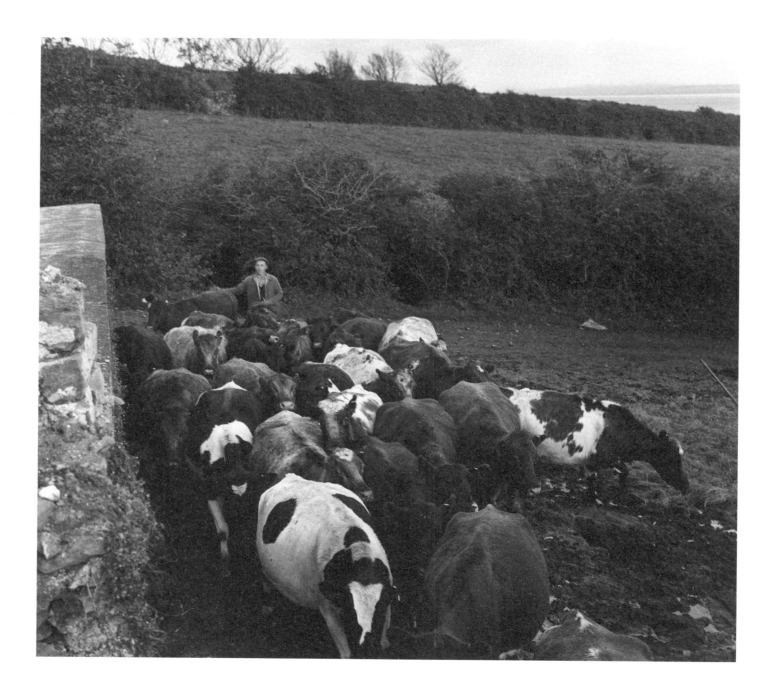

The Drover

To Meath of the pastures
From wet hills by the sea,
Through Leitrim and Longford,
Go my cattle and me.

I hear in the darkness
Their slipping and breathing –
I name them the bye-ways
They're to pass without heeding;

Then the wet, winding roads,
Brown bogs with black water,
And my thoughts on white ships
And the King o' Spain's daughter.

O farmer, strong farmer!
You can spend at the fair,
But your face you must turn
To your crops and your care;

And soldiers, red soldiers!
You've seen many lands,
But you walk two and two,
And by captain's commands.

O the smell of the beasts,
The wet wind in the morn,
And the proud and hard earth
Never broken for corn!

And the crowds at the fair,
The herds loosened and blind,
Loud words and dark faces,
And the wild blood behind!

(O strong men with your best
I would strive breast to breast,
I could quiet your herds
With my words, with my words!)

I will bring you, my kine,
Where there's grass to the knee,
But you'll think of scant croppings
Harsh with salt of the sea.

Pádraic Colum (1881 – 1972)

Bóithre Bána

Is fada uaim na bóithre,
Na bóithre fada, bán faoin ngréin,
Siar thar choim na má moiré
Go leisciúil leadránach ar strae.

In uaigneas caoin mo chuimhne
Cloisim naosc go géar gearr garbh
Amuigh i gciúnas na riasca
Ag buaireamh bhrionglóidí na marbh.

Asal dubh go smaointeach
Ag comhaireamh gach coiscéim dá shlí,
Cailín árd le cosa ríona
Ag tarraingt uisce i mbuicéidín.

Sráidbhaile ina chodladh
An deatach ina línte réidh,
Foscadh úr thar fráma dorais
Is cúmhracht dí i mbrothall laé.

Siar arís an bóthar,
Ór á leá i mbarra géag
Meisce mhilis an tráthnóna
Is an saol faoi dhraíocht ag dán an éin.

Uch is fada uaim na bóithre,
Na bóithre atá bán faoin ngréin,
Is ó ghleo na cathrach móire
Éalaíonn mo chuimhne leo ar strae.

Eoghan Ó Tuairisc (1919 – 1982)

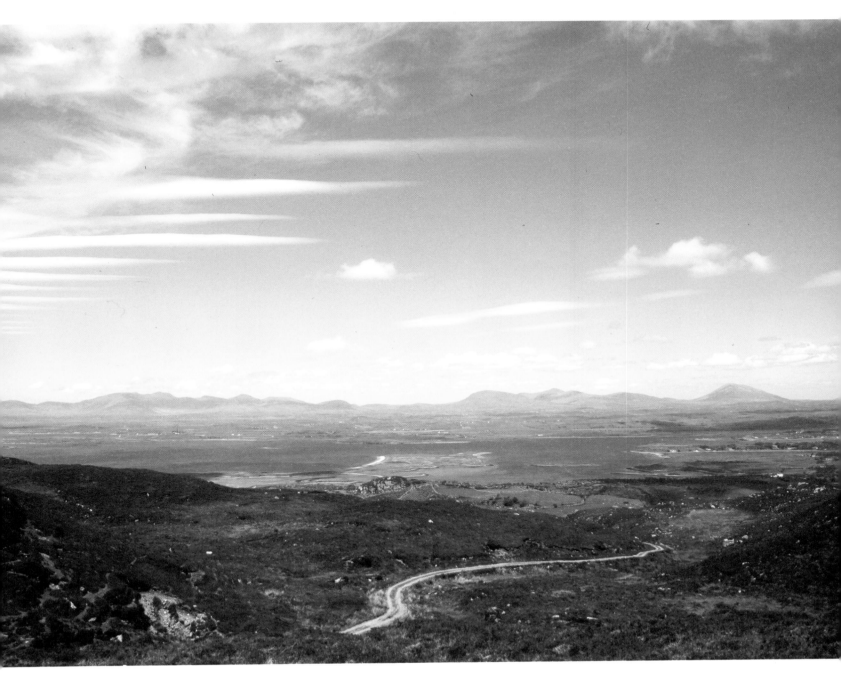

Prospect View.

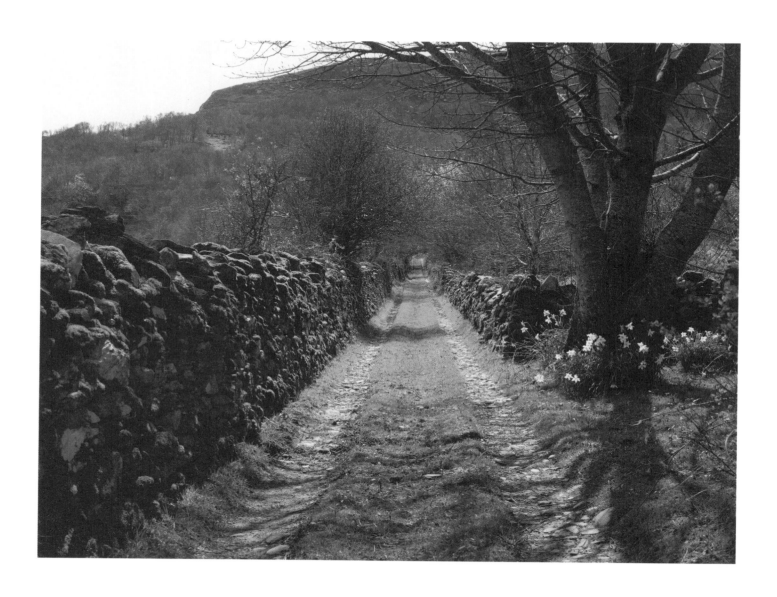

The Song of Wandering Aengus

I went out to the hazel wood,
Because a fire was in my head,
And cut and peeled a hazel wand,
And hooked a berry to a thread;
And when white moths were on the wing,
And moth-like stars were flickering out,
I dropped the berry in a stream
And caught a little silver trout.

When I had laid it on the floor
I went to blow the fire aflame,
But something rustled on the floor,
And someone called me by my name:
It had become a glimmering girl
With apple blossom in her hair
Who called me by my name and ran
And faded through the brightening air.

Though I am old with wandering
Through hollow lands and hilly lands,
I will find out where she has gone,
And kiss her lips and take her hands;
And walk among long dappled grass,
And pluck till time and times are done
The silver apples of the moon,
The golden apples of the sun.

William Butler Yeats (1865 – 1939)

Nature's Child

Still south I went, and west, and south again,
Through Wicklow from the morning to the night,
And far from cities and the sights of men,
Lived with the sunshine and the moon's delight.

I knew the stars, the flowers and the birds,
The grey and wintry sides of many glens,
And did but half remember human words,
In converse with the mountains, moors and fens.

J. M. Synge (1871 – 1909)

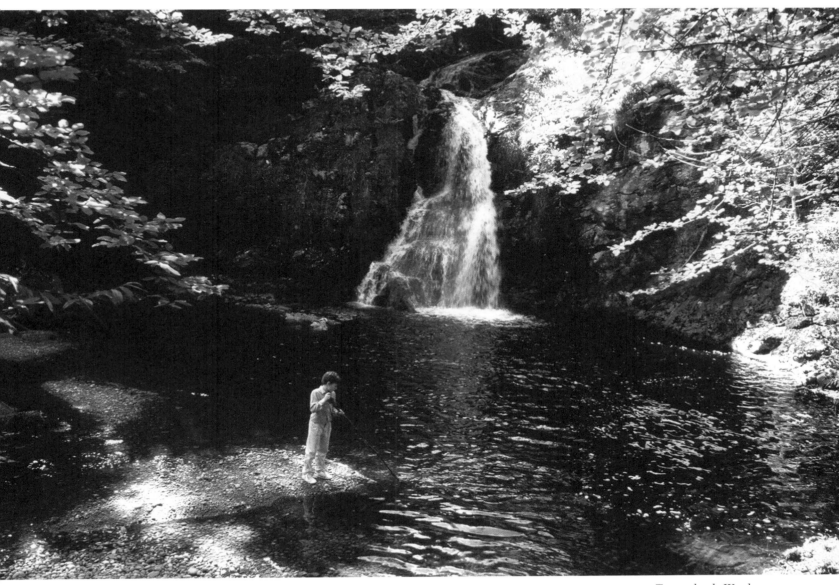

Tourmakeady Woods.

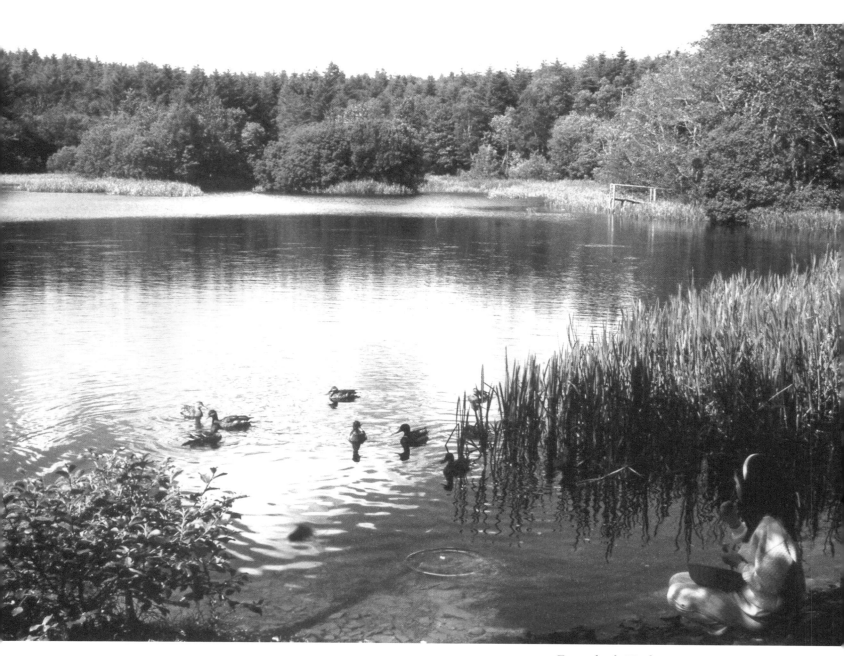

Tourmakeady Woods.

Four Ducks on a Pond

Four ducks on a pond,
A grass-bank beyond,
A blue sky of spring,
White clouds on the wing:
What a little thing
To remember for years –
To remember with tears!

William Allingham (1824 – 1889)

The Wild Swans at Coole

The trees are in their autumn beauty,
The woodland paths are dry,
Under the October twilight the water
Mirrors a still sky;
Upon the brimming water among the stones
Are nine-and-fifty swans.

The nineteenth autumn has come upon me
Since I first made count;
I saw, before I had well finished,
All suddenly mount
And scatter wheeling in great broken rings
Upon their clamorous wings.

I have looked upon those brilliant creatures,
And now my heart is sore.
All's changed since I, hearing at twilight,
The first time on this shore,
The bell-beat of their wings above my head,
Trod with a lighter tread.

Unwearied still, lover by lover,
They paddle in the cold
Companionable streams or climb the air;
Their hearts have not grown old;
Passion or conquest, wander where they will,
Attend upon them still.

But now they drift on the still water,
Mysterious, beautiful;
Among what rushes will they build,
By what lake's edge or pool
Delight men's eyes when I awake some day
To find they have flown away?

William Butler Yeats (1865 – 1939)

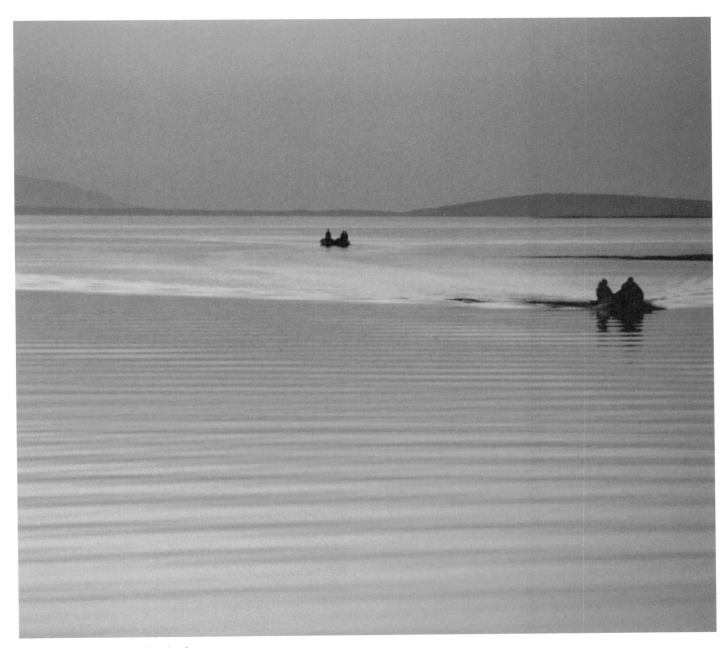

Coming home.

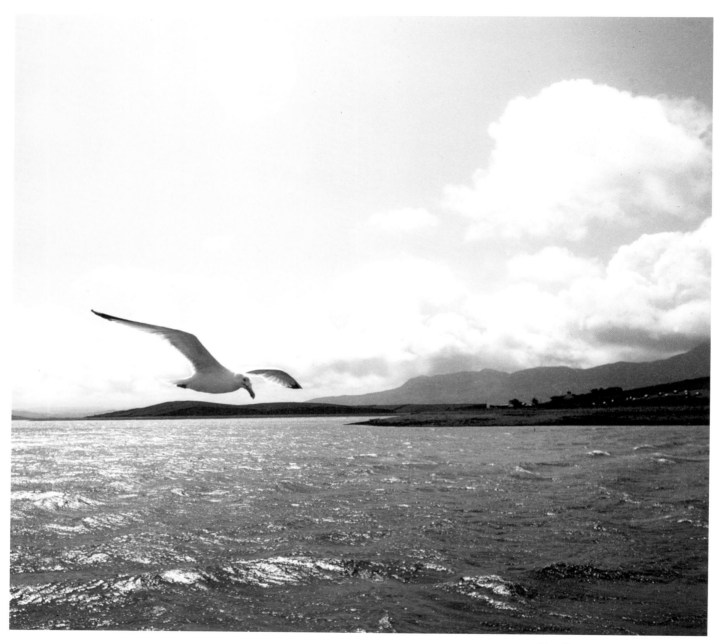

Clew Bay.

Lines to a Seagull

White bird of the tempest! O beautiful thing!
With the bosom of snow and the motionless wing,
Now sweeping the billow, now floating on high,
Now bathing thy plumes in the light of the sky,
Now poising o'er ocean thy delicate form,
Now breasting the surge with thy bosom so warm,
Now darting aloft with a heavenly scorn,
Now shooting along like a ray of the morn,
Now lost in the folds of the cloud-curtained dome,
Now floating abroad like a flake of the foam,
Now silently poised o'er the war of the main,
Like the spirit of Charity brooding o'er pain,
Now gliding with pinion all silently furled,
Like an angel descending to comfort the world!
Thou seem'st to my spirit, as upward I gaze,
And see thee, now clothed in mellowest rays,
Now lost in the storm-driven vapours that fly
Like hosts that are routed across the broad sky,
Like a pure spirit true to its virtue and faith,
'Mid the tempests of Nature, and passion, and death!

Rise, beautiful emblem of purity, rise!
On the sweet winds of Heaven to thine own brilliant skies;
Still higher – still higher – till lost to our sight,
Thou hidest thy wings in a mantle of light;
And I think, how a pure spirit gazing on thee,
Must long for the moment – the joyous and free –
When the soul disembodied from nature shall spring
Unfettered at once to her Maker and King;
When the bright day of service and suffering past,
Shapes fairer than thine shall shine round her at last,
While, the standard of battle triumphantly furled,
She smiles like a victor, serene on the world!

Gerald Griffin (1803 – 1840)

An Gleann 'nar Tógadh Mé

Ó áit go háit ba bhreá mo shiúl
'S dob ard mo léim ar bharr an tsléibh',
San uisce fíor ba mhór mo dhúil,
'S ba bheo mo chroí i lár mo chléibh;
Mar chois an ghiorria do bhí mo chos,
Mar iarann gach alt is féith,
Bhí an sonas romham, thall 's abhus,
Sa ghleann 'nar tógadh mé.

Ba chuma liomsa fear ar bith,
Ba chuma liom an domhan iomlán,
Mar rith an fhia do bhí mo rith,
Mar shruth an tsléibh' ag dul le fán;
Is ní raibh rud ar bith sa domhan
Nach ndearnas (dá mba mhaith liom é);
Do léim mo bhád ar bharr na habhann
Sa ghleann 'nar tógadh mé.

Gach ní dá bhfacas le mo shúil
Bhí sé, dar liom, ar dhath and óir;
Is annamh a dhearcainn ar mo chúl
Ach a' dul ar aghaidh le misneach mór;
Do leanainnse gan stad gan scíth
Mo rún (dá gcuirfinn romhamsa é);
Do bhéarfainn, dar liom, ar an ngaoith
Sa ghleann 'nar tógadh mé.

Ní hamhlaidh tá sé liom anois!
Do bhí mé luath, is tá mé mall;
Is é, mo léan, an aois do bhris
Sean-neart mo chroí is lúth mo bhall;
Do chaill mé mórán 's fuair mé fios
Ar mhórán – och! ní sású é –
Mo léan, mo léan gan mise arís óg
Sa ghleann 'nar tógadh mé.

Dubhghlas de hÍde (1860 – 1949)

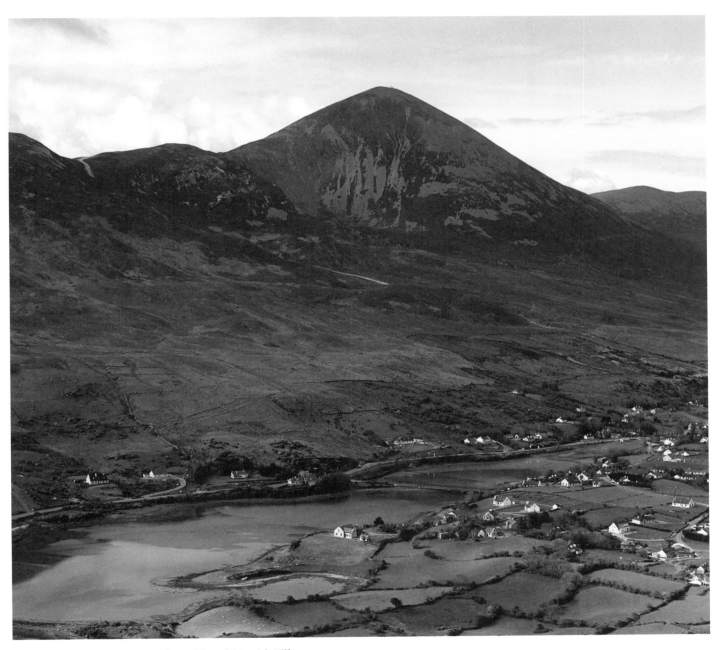

Croagh Patrick and Murrisk Village.

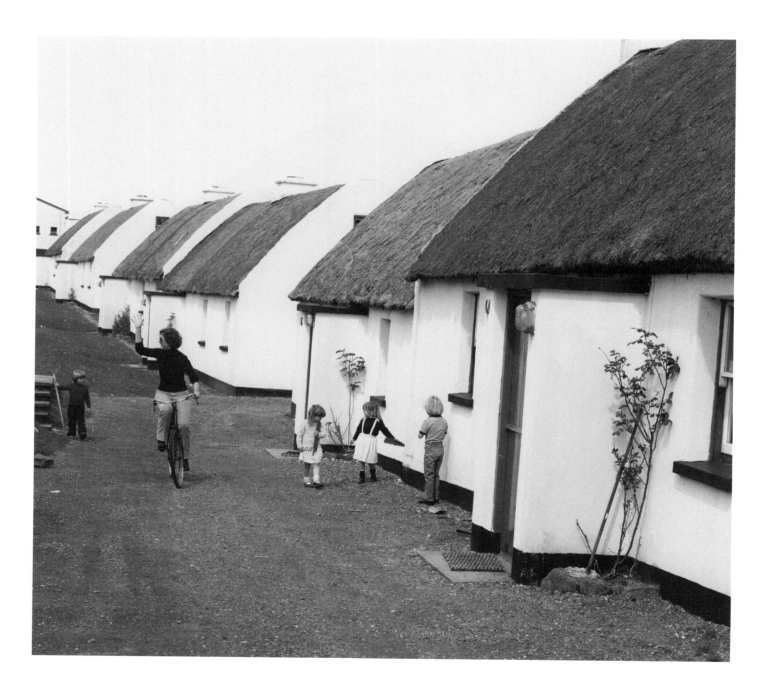

Queen of Connemara

Oh my boat can safely float in the teeth of wind and weather,
And outrace the fastest hooker between Galway and Kinsale;
When the black floor of the ocean and the white foam rush together,
High she rides in her pride like a seagull through the gale,

Oh she's neat, oh she's sweet,
She's a beauty in every line,
The Queen of Connemara
Is that bounding bark of mine.

When she's loaded down with fish,
Till the water laps the gunwhale,
Not a drop she'll take aboard her
That would wash a fly away;
From the fleet she speeds out quickly
Like a greyhound from her kennel,
Till she lands her silvery store the first
On old Kinvara Quay.

There's a light shines out afar
And it keeps me from dismaying
When the clouds are ink above us,
And the sea runs white with foam,
In a cot in Connemara
There's a wife and wee ones praying
To the One who walked the waters once
To bring us safely home.

Francis A. Fahy (1854 – 1935)

Achill

I lie and imagine a first light gleam in the bay
After one more night of erosion and nearer the grave,
Then stand and gaze from a window at break of day
As a shearwater skims the ridge of an incoming wave;
And I think of my son a dolphin in the Aegean,
A sprite among sails knife-bright in a seasonal wind,
And wish he were here where currachs walk on the ocean
To ease with his talk the solitude locked in my mind.

I sit on a stone after lunch and consider the glow
Of the sun through mist, a pearl bulb containèdly fierce;
A rain-shower darkens the schist for a minute or so
Then it drifts away and the sloe-black patches disperse.
Croagh Patrick towers like Naxos over the water
And I think of my daughter at work on her difficult art
And wish she were with me now between thrush and plover,
Wild thyme and sea-thrift, to lift the weight from my heart.

The young sit smoking and laughing on the bridge at evening
Like birds on a telephone pole or notes on a score.
A tin whistle squeals in the parlour, once more it is raining,
Turfsmoke inclines and a wind whines under the door;
And I lie and imagine the lights going on in the harbour
Of white-housed Náousa, your clear definition at night,
And wish you were here to upstage my disconsolate labour
As I glance through a few thin pages and switch off the light.

Derek Mahon (b. 1941)

52

A Cradle Song

O men from the fields!
 Come softly within.
Tread softly, softly,
 O men coming in!

Mavourneen is going
 From me and from you,
Where Mary will fold him
 With mantle of blue.

From reek of the smoke
 And cold of the floor,
And the peering of things
 Across the half-door.

O men from the fields!
 Softly, softly come thro'
Mary puts round him
 Her mantle of blue.

Pádraic Colum (1881 – 1972)

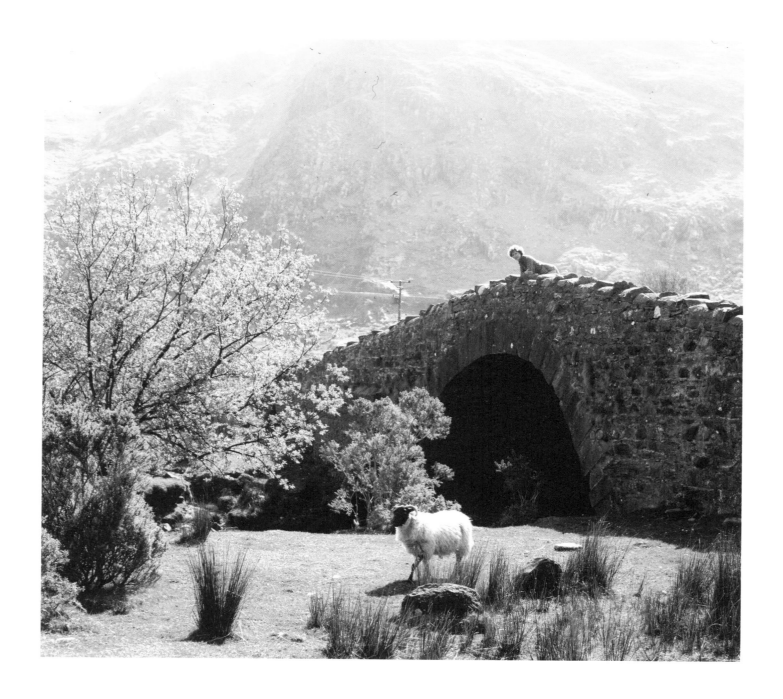

The Fairies

(A Child's Song)

Up the airy mountain
Down the rushy glen,
We daren't go a-hunting
For fear of little men;
Wee folk, good folk,
Trooping all together;
Green jacket, red cap,
And white owl's feather.

Down along the rocky shore
Some make their home –
They live on crispy pancakes
Of yellow tide-foam;
Some in the reeds
Of the black mountain lake,
With frogs for their watch-dogs,
All night awake.

By the craggy hill-side,
Through the mosses bare,
They have planted thorn trees
For pleasure here and there.
Is any man so daring
As dig one up for spite,
He shall find their sharpest thorns
In his bed at night.

Up the airy mountain,
Down the rushy glen,
We daren't go a-hunting
For fear of little men;
Wee folk, good folk,
Trooping all together;
Green jacket, red cap,
And white owl's feather!

William Allingham (1824 – 1889)

Down by the Salley Gardens

Down by the salley gardens my love and I did meet;
She passed the salley gardens with little snow-white feet.
She bid me take love easy, as the leaves grow on the tree;
But I, being young and foolish, with her did not agree.

In a field by the river my love and I did stand,
And on my leaning shoulder she laid her snow-white hand.
She bid me take life easy, as the grass grows on the weirs;
But I was young and foolish, and now am full of tears.

William Butler Yeats (1865 – 1939)

An tEarrach Thiar

Fear ag glanadh cré
De ghímseán spáide
Sa gciúineas shéimh
I mbrothall lae:
 Binn an fhuaim
 San Earrach thiar.

Fear ag caitheadh
Cliabh dhá dhroim,
Is an fheamainn dhearg
Ag lonnrú
I dtaitneamh gréine
Ar dhuirling bháin.
 Niamhrach an radharc
 San Earrach thiar.

Mná i locháin
In íochtar diaidh-thrá,
A gcótaí craptha,
Scáilí thíos fúthu:
 Támh-radharc síothach
 San Earrach thiar.

Toll-bhuillí fanna
Ag maidí rámha,
Currach lán éisc
Ag teacht chun cladaigh
Ar ór-mhuir mhall
I ndeireadh lae;
 San Earrach thiar.

Máirtín Ó Direáin (1910 – 1988)

57

Gortnamona

Long, long ago in the woods of Gortnamona,
I thought the birds were singing in the blackthorn tree;
But oh! It was my heart that was ringing, ringing, ringing,
With the joy that you were bringing O my love, to me.

Long, long ago, in the woods of Gortnamona,
I thought the wind was sighing round the blackthorn tree;
But oh! It was the banshee that was crying, crying, crying,
And I knew my love was dying far across the sea.

Now if you go through the woods of Gortnamona,
You hear the raindrops creeping through the blackthorn tree;
But oh! It is the tears I am weeping, weeping, weeping,
For the loved one that is sleeping far away from me.

Percy French (1854 – 1920)

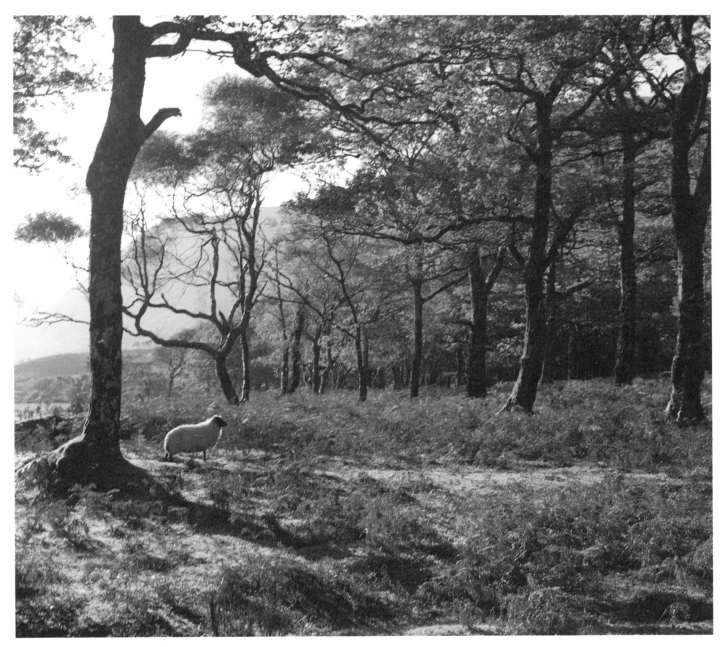

Erriff Wood.

Westport.

The County of Mayo

On the deck of Patrick Lynch's boat I sat in woeful plight,
Through my sighing all the weary day, and weeping all the night,
Were it not that full of sorrow from my people forth I go,
By the blessed sun! 'tis royally I'd sing thy praise, Mayo!

When I dwelt at home in plenty, and my gold did much abound,
In the company of fair young maids the Spanish ale went round –
'Tis a bitter change from those gay days that now I'm forced to go,
And must leave my bones in Santa Cruz, far from my own Mayo.

They are altered girls in Irrul now; 'tis proud they're grown and high,
With their hair-bags and their top-knots – for I pass their buckles by;
But it's little now I'll need their airs, for God will have it so,
That I must depart for foreign lands, and leave my sweet Mayo.

'Tis my grief that Patrick Loughlin is not Earl of Irrul still,
And that Brian Duff no longer rules as Lord upon the hill:
And that Colonel Hugh MacGrady should be lying dead and low,
And I sailing, sailing swiftly from the county of Mayo.

George Fox (b. 1809 – ?1880)

The Hills of Connemara

The night mist thickens o'er the town,
 The twilight's paling dimmer,
And through the chill, hum-laden air
 The gaslights faintly glimmer.
In exile here I sit and think,
 My heart surcharged with sorrow,
Of home, and friends that watch for me
 On the hills of Connemara –
Those glorious hills, those kindly hills,
 The hills of Connemara!

The night mist thickens o'er the town,
 But heavier mists are falling
On the Irish breast, bereft of love,
 For peace and rest long calling.
Alone! alone! where millions throng,
 As if my brain to harrow
With golden dreams of thundering streams
 On the hills of Connemara –
The loving hills, the wild-eyed hills,
 The hills of Connemara.

On Corrib's cheeks the moonlight sleeps,
 The currach skims full lightly;
O'er Clifden's slopes our mountain girls
 Now wander singing blithely;
And I must bear this strife and din,
 While memory strives to borrow
One look of love, one sparkling glance
 Of the hills of Connemara.
O soft-faced hills! O brown-tipped hills!—
 Brave hills of Connemara.

John Keegan Casey (1846 – 1870)

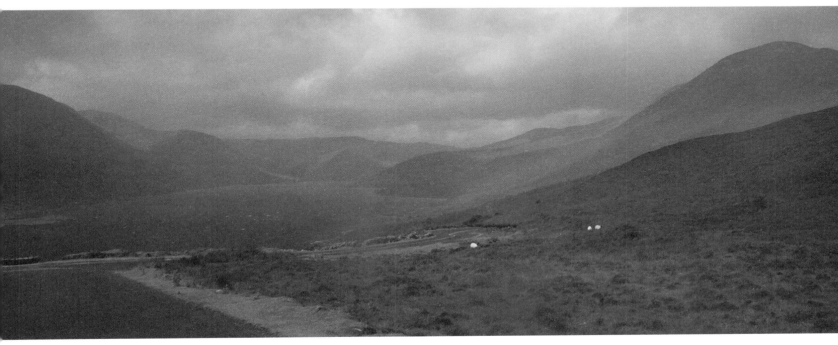

Lough na Fooey rainbow.

The Deserted Village

Extract

Sweet Auburn! Parent of the blissful hour,
Thy glades forlorn confess the tyrant's power.
Here, as I take my solitary rounds,
Amidst thy tangling walks and ruined grounds,
And, many a year elapsed, return to view
Where once the cottage stood, the hawthorn grew,
Remembrance wakes with all her busy train,
Swells at my breast and turns the past to pain.

In all my wanderings round this world of care,
In all my griefs – and God has given my share –
I still had hopes, my latest hours to crown,
Amidst these humble bowers to lay me down;
To husband our life's taper to the close,
And keep the flame from wasting by repose:
I still had hopes, for pride attends us still,
Amidst the swains to show my book-learned skill,
Around my fire and evening group to draw,
And tell of all I felt, and all I saw;
And, as a hare whom hounds and horns pursue
Pants to the place from whence at first she flew,
I still had hopes, my long vexations past,
Here to return—and die at home at last.

Sweet was the sound, when oft at evening's close
Up yonder hill the village murmur rose;
There as I passed with careless steps and slow,
The mingling notes came softened from below;
The swain responsive as the milk-maid sung,
The sober herd that lowed to meet their young:
The noisy geese that gabbled o'er the pool,
The playful children just let loose from school;
The watch-dog's voice that bayed the whispering
wind,
And the loud laugh that spoke the vacant mind:—
These all in sweet confusion sought the shade,
And filled each pause the nightingale had made.
But now the sounds of population fail,
No cheerful murmurs fluctuate in the gale,
No busy steps the grass-grown footway tread,
For all the bloomy flush of life is fled.

Near yonder copse, where once the garden smiled,
And still where many a garden flower grows wild;
There, where a few torn shrubs the place disclose,
The village preacher's modest mansion rose.
A man he was to all the country dear,
And passing rich with forty pounds a year;
Remote from towns he ran his godly race,
Nor e'er had changed, nor wished to change his place:
Unpractised he to fawn, or seek for power,
By doctrines fashioned to the varying hour;
Far other aims his heart had learned to prize,
More skilled to raise the wretched than to rise.
His house was known to all the vagrant train,
He chid their wanderings, but relieved their pain;
The long-remembered beggar was his guest,
Whose beard descending swept his aged breast;
The ruined spendthrift, now no longer proud,
Claimed kindred there, and had his claims allowed,

The broken soldier, kindly bade to stay,
Sat by his fire, and talked the night away,
Wept o'er his wounds, or tales of sorrow done,
Shouldered his crutch and showed how fields were won.
Pleased with his guests, the good man learned to glow,
And quite forgot their vices in their woe;
Careless their merits or their faults to scan,
His pity gave ere charity began.

Thus to relieve the wretched was his pride,
And even his failings leaned to virtue's side:
But in his duty, prompt at every call,
He watched and wept; he prayed and felt for all:
And, as a bird each fond endearment tries
To tempt its new-fledged offspring to the skies,
He tried each art, reproved each dull delay,
Allured to brighter worlds, and led the way.

Beside the bed where parting life was laid,
And sorrow, guilt, and pain by turns dismayed,
The reverend champion stood. At his control
Despair and anguish fled the struggling soul;
Comfort came down the trembling wretch to raise,
And his last faltering accents whispered praise.

At church, with meek and unaffected grace,
His looks adorned the venerable place;
Truth from his lips prevailed with double sway,
And fools, who came to scoff, remained to pray.
The service past, around the pious man,
With steady zeal, each honest rustic ran;
Even children followed, with endearing wile,
And plucked his gown, to share the good man's smile:
His ready smile a parent's warmth expressed,
Their welfare pleased him, and their cares distressed;
To them his heart, his love, his griefs were given,
But all his serious thoughts had rest in heaven;

As some tall cliff that lifts its awful form,
Swells from the vale, and midway leaves the storm,
Though round its breast the rolling clouds are spread,
Eternal sunshine settles on its head.

Beside yon straggling fence that skirts the way
With blossomed furze unprofitably gay—
There, in his noisy mansion, skilled to rule,
The village master taught his little school:
A man severe he was, and stern to view,
I knew him well, and every truant knew;
Well had the boding tremblers learned to trace
The day's disasters in his morning face;
Full well they laughed with counterfeited glee
At all his jokes, for many a joke had he;
Full well the busy whisper, circling round,
Conveyed the dismal tidings when he frowned:
Yet he was kind, or if severe in aught,
The love he bore to learning was at fault.
The village all declared how much he knew;
'Twas certain he could write and cipher too:
Lands he could measure, terms and tides presage
And even the story ran that he could gauge.
In arguing, too, the parson owned his skill,
For e'en though vanquished, he could argue still;
While words of learned length and thundering sound
Amazed the gazing rustics ranged around;
And still they gazed, and still their wonder grew
That one small head could carry all he knew.

But past is all his fame. The very spot,
Where many a time he triumphed, is forgot.

Oliver Goldsmith (1730 – 1774)

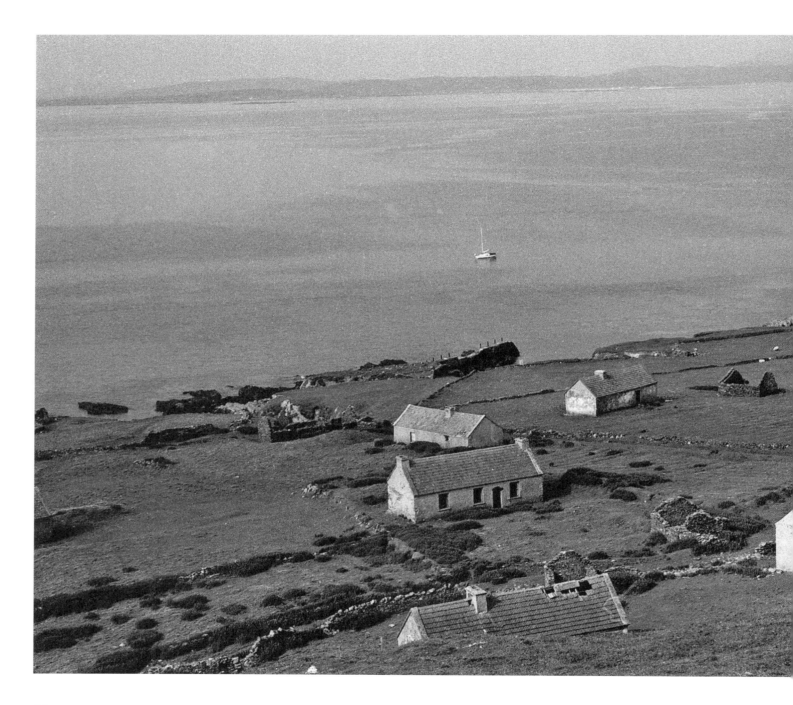

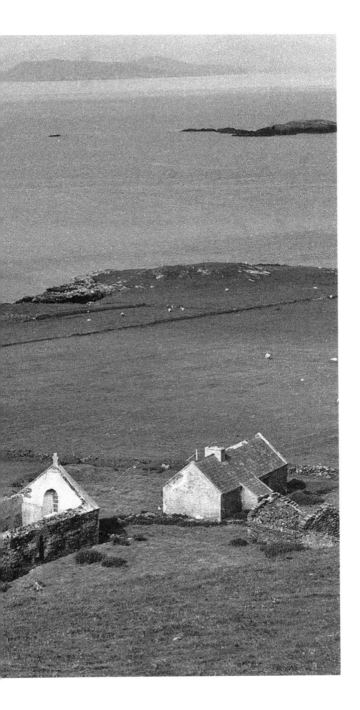

Inishshark.

Siar a Raghadsa

Siar a raghadsa féin
Go hoileán mara i gcéin
Ar theacht an fhómhair bhuí
Le háthas is aiteas croí.

San oileán mara thiar
Beidh fáilte romham is céad;
Fáilte fhairsing, fáilte fhial,
San oileán mara thiar.

Máirtín Ó Direáin (1910 – 1988)

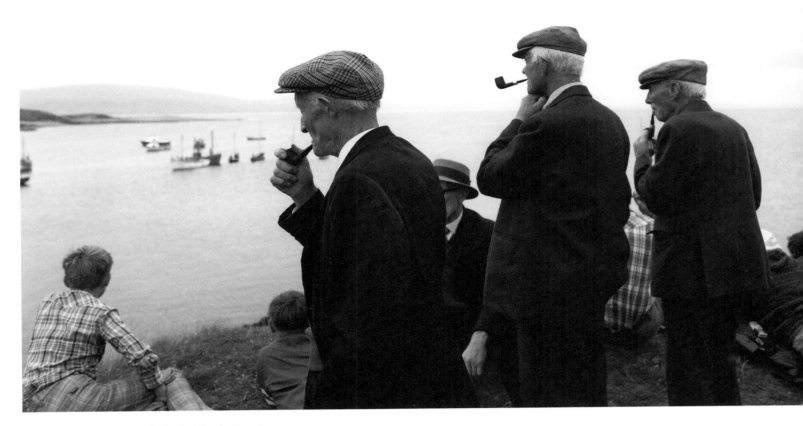

Gathering for the Regatta.

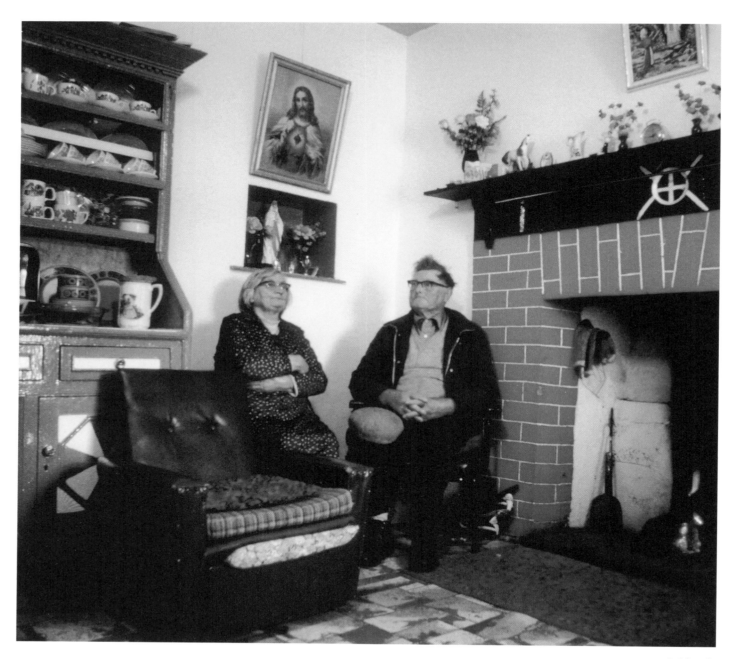

Inishturk.

The Dwelling

At night the house grows
Around the blackshawled woman. Harsh
And sparse the bony room
But with the lamp
All the pieces give their lights:
She shines among her satellites.

Man-chairs of oak, scrubbed; a rack
Of cups and blue plates;
The tabled jug:
The oilcloth spreading from the wick;
The spindled stair without a rug
But scrubbed, scrubbed to the quick.

The tiny window's shut its eye;
Let the strand roar
And the white horses tumble on the shore,
Here catgreen
The salt driftwood purrs inside the fire
And the sea ends that pours around the world.

Somewhere and old working clock,
Weights and chains, ticks on and tells
The woman's hours;
The wether's wool in the knitted sock,
The world weather in
Her knotted face, her knotted talk;
How men come home
From the ocean drip, still rocking, ill at ease
Till she gathers them;
Here she sets them down in peace
Inside the lamp, the house, the shawl.
Here is the centre of them all.

And all the pieces hang
In one. The man is on the chair
Who winds the clock
Who'll climb the stairhead after her,
Adjust the wick
Till the great night idles, barely ticking over.

Padraic Fallon (1906 – 1974)

In Exile

This London sky is dull and grey;
 A storm of sleet and rain
Is beating dismally today
 Upon my window pane.
On wings of fancy let me stray
 To summer shores again.

Once more the fresh Atlantic breeze
 Its friendly greeting cries;
A far across the azure seas
 The cliffs of Achill rise
And cloudlands countless pageantries
 Sweep through the sunlit skies.

The distance fills with misty hills,
 Alternate gleam and gloom;
I see again the purple plain
 Bestarred with golden broom,
Whilst at my feet the meadowsweet
 Pours forth its faint perfume.

So when along the Achill Sound
 The summer sunset gleams,
And when the heather bells are found,
 Beside the mountain streams,
I'll seek thy shore and live once more,
 Oh island of my dreams!

Percy French (1854 – 1920)

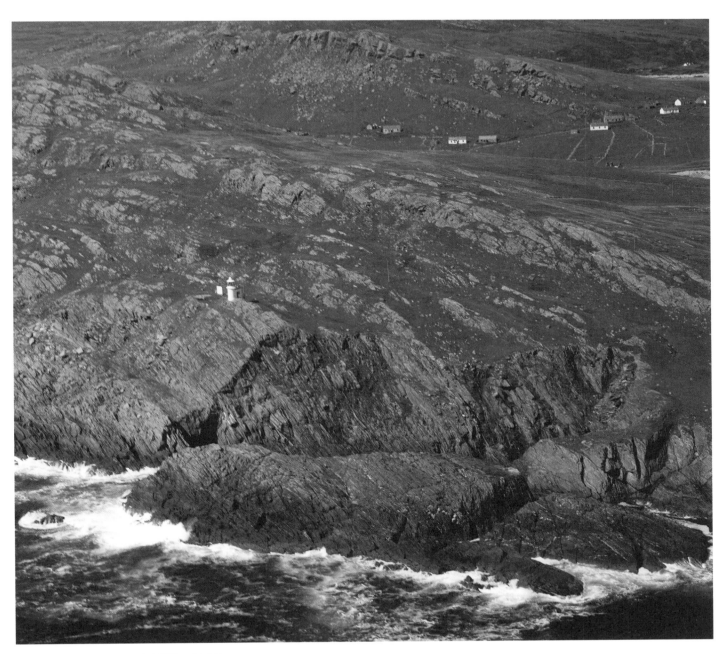

Achill Beg Lighthouse.

'Tis, it is the Shannon's Stream

'Tis, it is the Shannon's stream,
Brightly glancing, brightly glancing!
See, oh see the ruddy beam
Upon its waters dancing!
To see old Shannon's face again,
Oh, the bliss entrancing!
Hail, our own majestic stream
Flowing ever, flowing ever,
Silent, in the morning beam,
Our beloved river!

Fling the rocky portals wide,
Western ocean, western ocean!
Bend, ye hills, on either side,
In solemn, deep devotion!
While before the rising gales,
On his heaving surface sails
Half the wealth of Erin's vales
With undulating motion.
Hail, our own beloved stream,
Flowing ever, flowing ever,
Silent in the morning beam,
Our own majestic river!

Gerald Griffin (1803 – 1840)

The Wayfarer

The beauty of the world hath made me sad,
This beauty that will pass;
Sometimes my heart hath shaken with great joy
To see a leaping squirrel in a tree,
Or a red lady-bird upon a stalk
Or little rabbits in a field at evening,
Lit by a slanting sun,
Or some green hill where shadows drifted by,
Some quiet hill where mountainy men hath sown
And soon would reap, near to the gate of Heaven;
Or children with bare feet upon the sands
Of some ebbed sea, or playing on the streets
Of little towns in Connacht,
Things young and happy.
And then my heart hath told me:
These will pass,
Will pass and change, will die and be no more,
Things bright and green, things young and happy;
And I have gone upon my way
Sorrowful.

Pádraig H. Pearse (1879 – 1916)

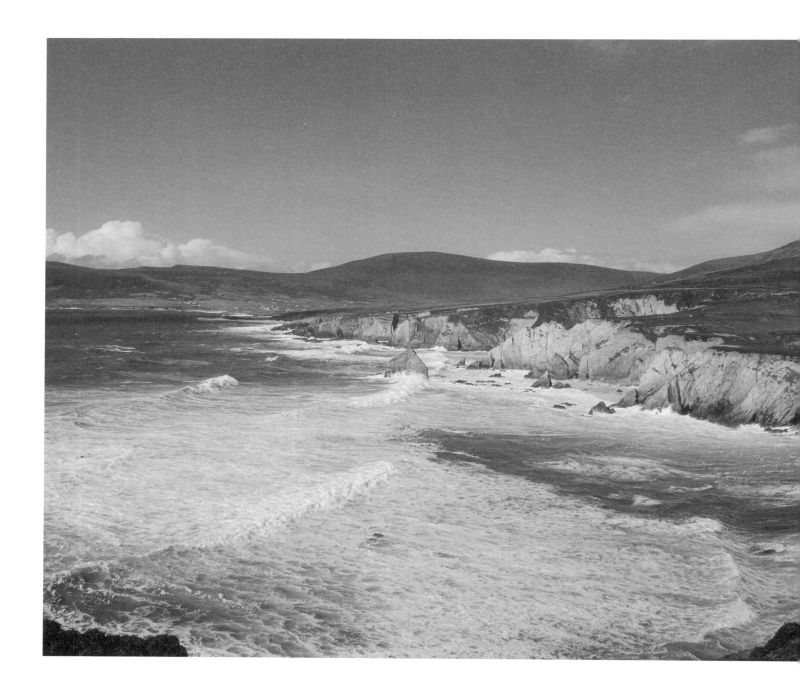

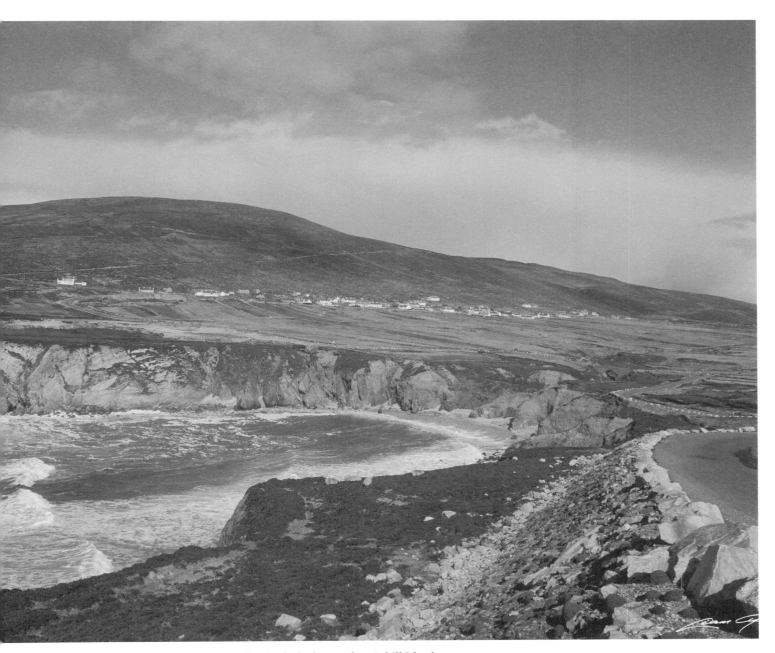

Ashleam Village in the background on Achill Island.

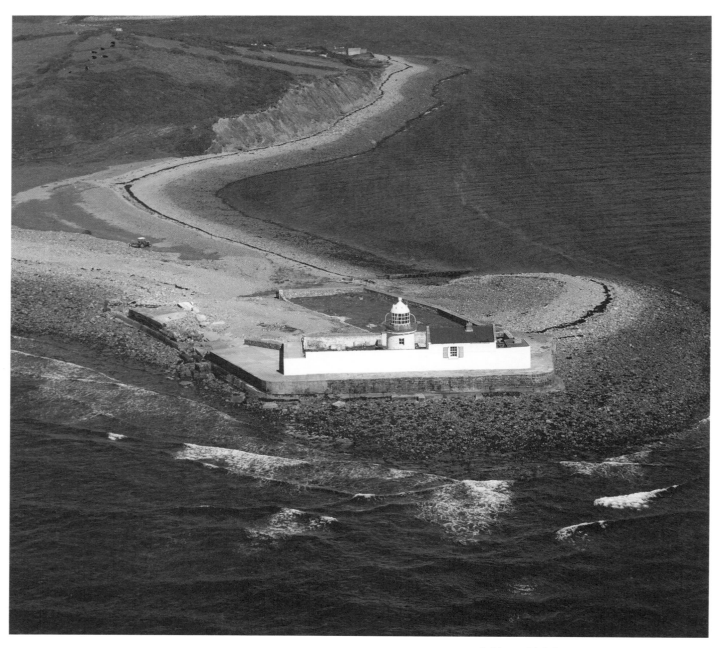

Inishgort Lighthouse.

Tháinig long ó Valparaiso

Tháinig long ó Valparaiso,
Scaoileadh téad a seol sa chuan,
Chuir a hainm dom i gcuimhne
Ríocht na Gréine, Tír na mBua.

'Gluais,' ar sí, ar thuras fada
Liom ó scamall is ó cheo;
Tá fé shleasaibh gorm- Andes
Cathair scáfar, glé mar sheod.'

Ach bhíos óg is ní imeoinnse,
Am an dóchais, tús mo shaoil;
Chreideas fós go raibh in ann dom
Iontaisí na ndán 'sna scéal.

Ghluais an long thar linntibh mara
Fad' ó shin 's a crann mar ór,
Scríobh a scéal ar phár na hoíche,
Ard i rian na réiltean mór.

Fillfidh sí arís chugam, áfach;
Chifead cathair bhán fén sléibh
Le hais Mara na Síochána –
Creidim fós, beagnach, a Dhé.

Pádraig de Brún (1889 – 1960)

The Clare Island Survey

I have the sketch of Clare Island,
in your hand. You drew the great brow
in silhouette from the mainland,
and scribbled gulls over a blue sound,
then etched a furze bush
with pencilled spikes in the foreground
and, in between, some trees, a slate roof
and a red gable huddling together.
No sooner had I left two years ago
than you made our trip, on your own, to Mayo.

2

It lures me back, seawards,
to a headland of thrift and stone
where July strikes cold with its bluster –
and already there's no getting away,
the native speakers are shouldering my boat
to the slipway. I float her
and fill her with my tackle (rain gear,
a sooty kettle), then pay the interpreter
and row out alone into heavy waters,
where the gulls come into their own.

3

So I turn to Clare Island, and approach,
as they line up on the pier
and jostle for place, the forefathers
ready to construe my coming,
unwilling to believe that I am strange
to the old score of grant and annexation.
And I step ashore, deaf to their questions,
my pages blank for the whims of the day.
Here I will inscribe readings
for the Clare Island Survey.

4

Gillie or squire in the first photographs,
going far out to give the scale
with a yardstick as a staff,
remote, unnamed, a small notch,
I would be measured against you,
and will lose face, pacing out
in the footsteps of the early workers
to where fatigue compels the heart,
and return then, my face aglow
with a booty of old words, and new echoes.

Seán Lysaght (b.1957)

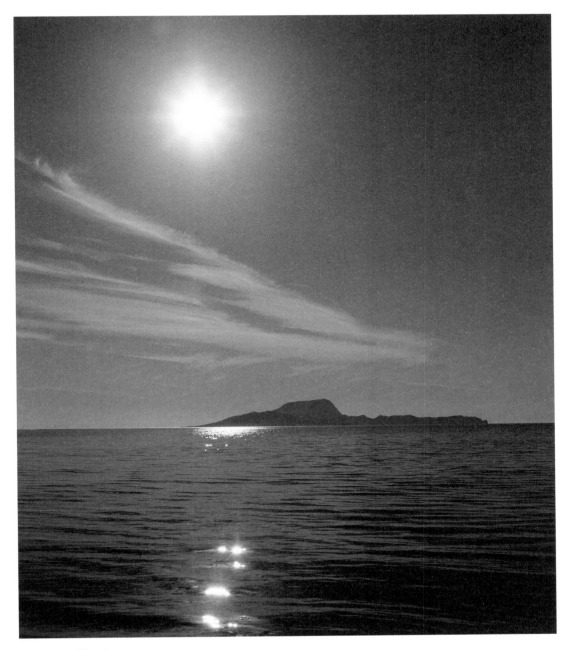

Clew Bay.

When You Are Old

When you are old and grey and full of sleep,
And nodding by the fire, take down this book,
And slowly read, and dream of the soft look
Your eyes had once, and of their shadows deep;

How many loved your moments of glad grace,
And loved your beauty with love false or true,
But one man loved the pilgrim soul in you,
And loved the sorrows of your changing face;

And bending down beside the glowing bars,
Murmur, a little sadly, how Love fled
And paced upon the mountains overhead
And hid his face amid a crowd of stars.

William Butler Yeats (1865 – 1939)

Years Later

From 'The Cleggan Disaster'

Whose is that hulk on the shingle
The boatwright's son repairs,
Though she has not been fishing
For thirty-four years
Since she rode the disaster?
The oars were turned into rafters
For a roof stripped by a gale.
Moss has grown on her keel.

Where are the red-haired women
Chattering among the piers
Who gutted millions of mackerel
And baited the spillet hooks
With mussels and lug-worms?
All the hurtful hours
Thinking the boats were coming
They hold against those years.

Where are the barefoot children
With brown toes in the ashes
Who went to the well for water,
Picked winkles on the beach
And gathered sea-rods in winter?
The lime is green on the stone
Which they once white-washed.
In summer nettles return.

Where are the dances in houses
With porter and cakes in the room,
The reddled faces of fiddlers
Sawing out jigs and reels,
The flickering eyes of neighbours?
The thatch which was neatly bordered
By a fringe of sea-stones
Has now caved in.

Why does she stand at the curtains
Combing her seal-grey hair
And uttering bitter opinions
On land-work and sea-fear,
Drownings and famines?
When will her son say
'Forget about the disaster,
We're mounting nets today!'

Richard Murphy (b. 1927)

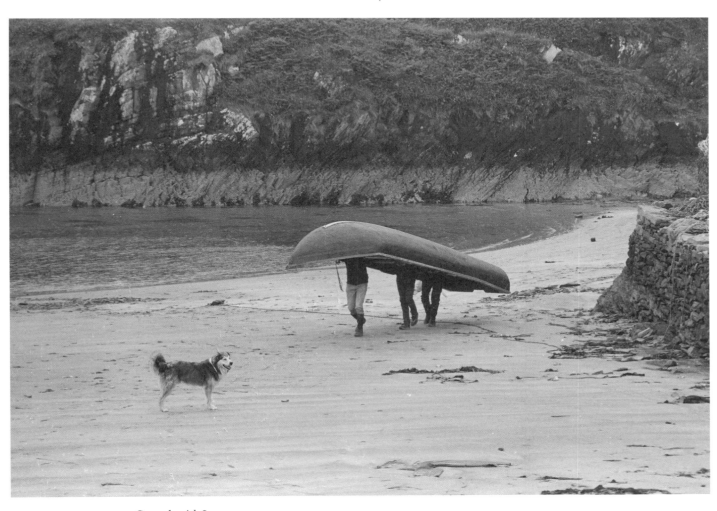

Currach with Legs.

Remains of Doon Castle.

The Nameless Doon

Who were the builders? Question not the silence
That settles on the lake for evermore,
Save when the sea-bird screams and to the islands
The echo answers from the steep-cliffed shore.
O half-remaining ruin, in the lore
Of human life a gap shall all deplore
Beholding thee; since thou art like the dead
Found slain, no token to reveal the why,
The name, the story. Some one murdered
We know, we guess; and gazing upon thee,
And, filled by the long silence of reply,
We guess some garnered sheaf of tragedy;
Of tribe or nation slain so utterly
That even their ghosts are dead, and on their grave
Springeth no bloom of legend in its wildness;
And age by age weak washing round the islands
No faintest sigh of story lisps the wave.

William Larminie (1849 – 1900)

The Grave of Rury

Clear as air, the western waters
Evermore their sweet, unchanging song
Murmur in their stony channels
Round O'Connor's sepulchre in Cong.

Crownless, hopeless, here he lingered;
Year on year went by him like a dream,
While the far-off roar of conquest
Murmured faintly like the singing stream.

Here he died, and here they tombed him,
Men of Feichín, chanting round his grave.
Did they know, ah! did they know it,
What they buried by the babbling wave?

Now above the sleep of Rury
Holy things and great have passed away;
Stone by stone the stately Abbey
Falls and fades in passionless decay.

Darkly grows the quiet ivy,
Pale the broken arches glimmer through;
Dark upon the cloister-garden
Dreams the shadow of the ancient yew.

Through the roofless aisles the verdure
Flows, the meadow-sweet and fox-glove bloom.
Earth, the mother and consoler,
Winds soft arms about the lonely tomb.

Peace and holy gloom possess him,
Last of Gaelic monarchs of the Gael,
Slumbering by the young, eternal
River-voices of the western vale.

T. W. Rolleston (1857 – 1920)

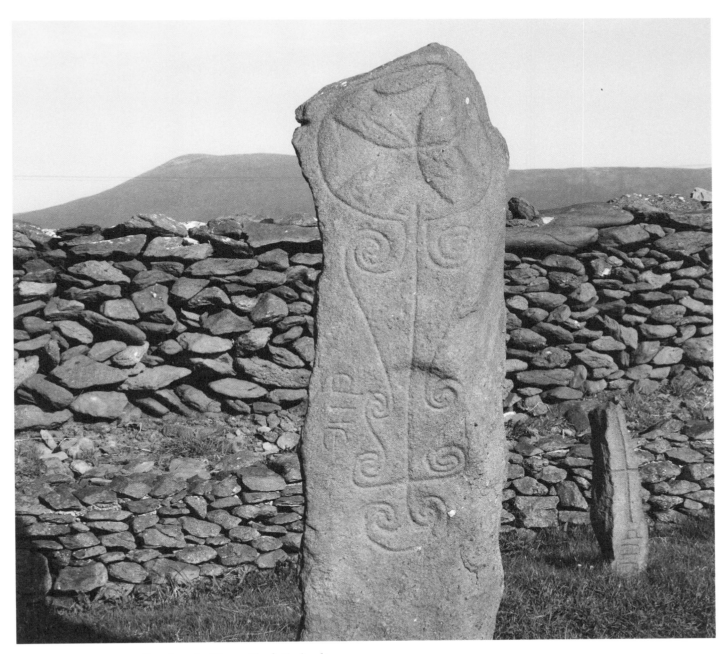

Cross Inscribed Stone, Dingle Peninsula.

A Vision of Connaught in the Thirteenth Century

I walked entranced
 Through a land of Morn;
The sun, with wondrous excess of light,
 Shone down and glanced
 Over seas of corn
And lustrous gardens aleft and right.
 Even in the clime
 Of resplendent Spain,
Beams no such sun upon such a land;
 But it was the time,
 'Twas in the reign,
Of Cathal Mór of the Wine-red hand.

Anon stood nigh
 By my side a man
Of princely aspect and port sublime.
 Him queried I –
 'Oh my Lord and Khan,
What clime is this, and what golden time?'
 When he – 'The clime
 Is a clime to praise,

The clime is Erin's, the green and bland;
 And it is the time,
 These be the days
Of Cathal Mór of the Wine-red Hand!'

Then saw I thrones,
 And circling fires,
And a Dome rose near me, as by a spell,
 Whence flowed the tones
 Of silver lyres,

And many voices in wreathed swell;
 And their thrilling chime
 Fell on mine ears
As the heavenly hymn of an angel-band –
 'It is now the time,
 These be the years,
Of Cathal Mór of the Wine-red Hand!'

I sought the hall,
 And, behold! – a change
From light to darkness, from joy to woe!
 King, nobles, all,
 Looked aghast and strange;
The minstrel-group sate in dumbest show!
 Had some great crime
 Wrought this dread amaze,
This terror? None seemed to understand
 'Twas then the time,
 We were in the days,
Of Cathal Mór of the Wine-red Hand.

I again walked forth;
 But lo! The sky
Showed fleckt with blood, and an alien sun
 Glared from the north,
 And there stood on high,
Amid his shorn beams, a skeleton!
 It was by the stream
 Of the castled Maine,

One Autumn eve, in the Teuton's land,
 That I dreamed this dream
 Of the time and reign
Of Cathal Mór of the Wine-red Hand!

James Clarence Mangan (1803 – 1849)

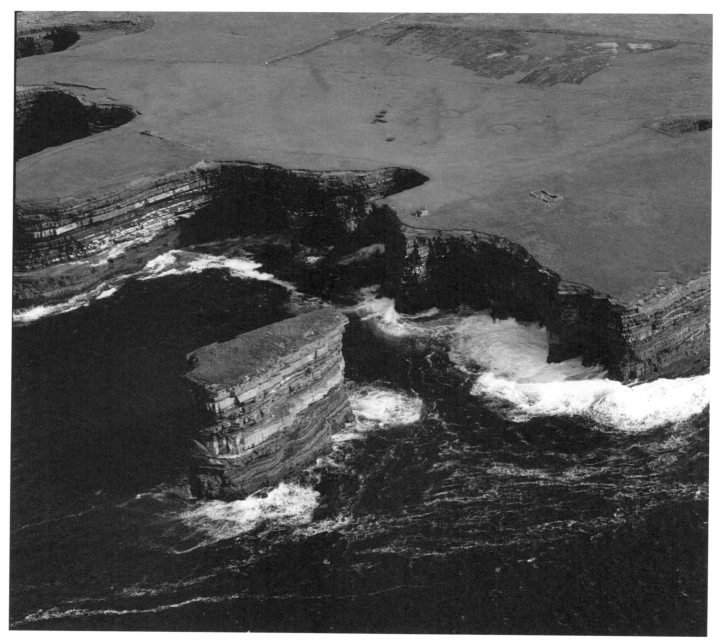

Dun Briste.

After Aughrim

She said, 'They gave me of their best,
They lived, they gave their lives for me;
I tossed them to the howling waste,
And flung them to the foaming sea.'

She said, 'I never gave them aught,
Not mine the power, if mine the will;
I let them starve, I let them bleed –
They bled and starved, and loved me still.'

She said, 'Ten times they fought for me,
Ten times they strove with might and main,
Ten times I saw them beaten down,
Ten times they rose, and fought again.'

She said, 'I never called them sons,
I almost ceased to breathe their name,
Then caught it echoing down the wind,
Blown backwards from the lips of Fame.'

She said, 'Not mine, not mine that fame;
Far over sea, far over land,
Cast forth like rubbish from my shores,
They won it yonder, sword in hand.'

She said, 'God knows they owe me nought,
I tossed them to the foaming sea,
I tossed them to the howling waste,
Yet still their love comes home to me.'

Emily Lawless (1845 – 1913)

Red Hanrahan's Song About Ireland

The old brown thorn trees break in two high over Cummen Strand,
Under a bitter black wind that blows from the left hand;
Our courage breaks like an old tree in a black wind and dies,
But we have hidden in our hearts the flame out of the eyes
O Cathleen, the daughter of Houlihan.

The wind has bundled up the clouds high over Knocknarea,
And thrown the thunder on the stones for all that Maeve can say.
Angers that are like noisy clouds have set our hearts abeat;
But we have all bent low and low and kissed the quiet feet
Of Cathleen, the daughter of Houlihan.

The yellow pool has overflowed high up on Clooth-na-Bare,
For the wet winds are blowing out of the clinging air;
Like heavy flooded waters our bodies and our blood;
But purer than a tall candle before the Holy Rood
Is Cathleen, the daughter of Houlihan.

William Butler Yeats (1865 – 1939)

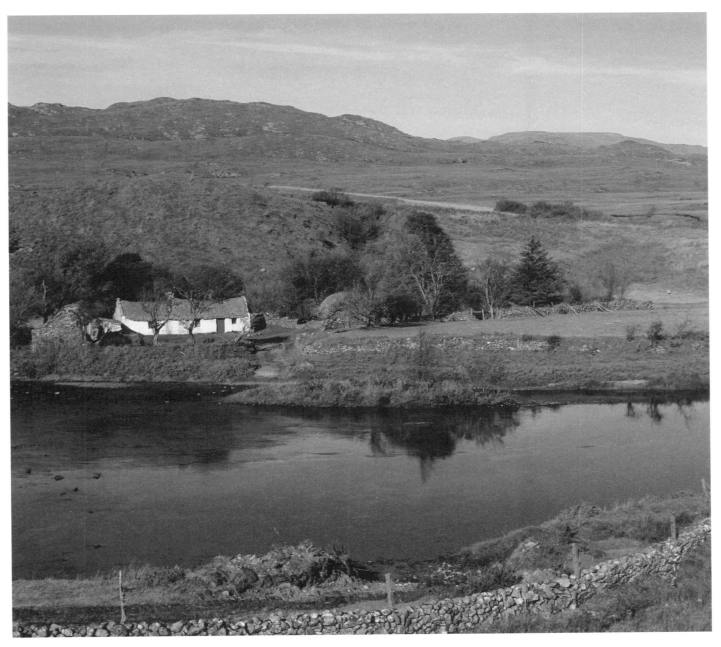

Erriff.

Bean tSléibhe ag Caoíneadh a Mic

Brón ar an mbás, 'sé dhubh mo chroíse,
D'fhuadaigh mo ghrá is d'fhág mé cloíte,
Gan charaid gan chompánach faoí dhíon mo thí-se,
Ach an lean seo im' lár, is mé ag caoineadh!

Ag gabháil an tsléibhe dhom tráthnóna
Do labhair an éanlaith liom go brónach,
Do labhair an naosc binn 's an crotach glórach
Ag faisnéis dom gur éag mo stórach.

Do ghlaoigh mé ort is do ghlór níor chualas,
Do ghlaoígh mé arís, is freagra ní bhfuaireas,
Do phóg mé do bhéal, is a Dhia, nárbh fhuar é! –
Och, is fuar í do leaba sa chillín uaigneach.

'S a uaigh fhódghlas ina bhfuil mo leanbh,
A uaigh chaol bheag, ós tú a leaba,
Mo bheannacht ort, 's na mílte beannacht
Ar na fóda glasa atá ós cionn mo pheata.

Brón ar an mbás, ní féidir a shéanadh,
Leagann sé úr is críon le chéile –
'S a mhaicín mhánla, is é mo chéasadh
Do cholainn chaomh bheith ag déanamh créafóig'.

Pádraig Mac Piarais (1879 – 1916)

Connemara

The soft rain is falling
 Round bushy isles,
Veiling the waters
 Over wet miles,
And hushing the grasses
 Where plovers call,
While soft clouds are falling
 Over all.

I pulled my new currach
 Through the clear sea
And left the brown sailings
 Far behind me,
For who would not hurry
 Down to the isle,
Where Una has lured me
 With a smile.

She moves through her sheiling
 Under the haws,
Her movements are softer
 Than kitten's paws;
And shiny blackberries
 Sweeten the rain,
Where I haunt her beaded
 Window-pane.

I would she were heeding –
 Keeping my tryst –
That soft moon of amber
 Blurred in the mist,
And rising the plovers
 Where salleys fall
Till slumbers come hushing
 One and all.

F. R. Higgins (1896 – 1941)

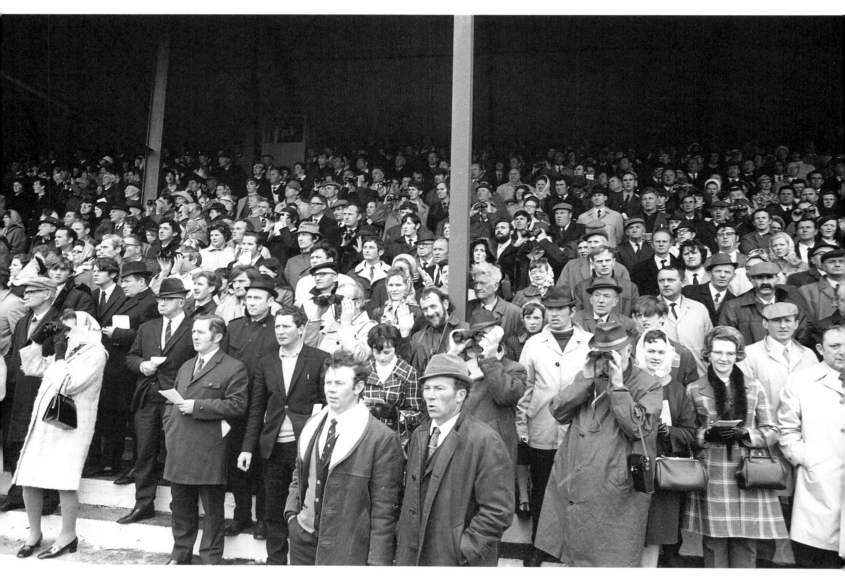

Ballinrobe Races.

Galway Races

It's there you'll see confectioners with sugar sticks and dainties,
The lozenges and oranges, lemonade and the raisins;
The gingerbread and spices to accommodate the ladies,
And a big crubeen for threepence to be picking while you're able.

It's there you'll see the gamblers, the thimbles and the garters,
And the sporting Wheel of Fortune with the four and twenty quarters.
There was others without scruple pelting wattles at poor Maggy,
And her father well contented and he looking at his daughter.

It's there you'll see the pipers and the fiddlers competing,
And the nimble-footed dancers and they tripping on the daisies.
There was others crying segars and lights, and bills of all the races,
With the colours of the jockeys, the prize and horses' ages.

It's there you'll see the jockeys and they mounted on most stately,
The pink and blue, the red and green, the Emblem of our notion.
When the bell was rung for starting, the horses seemed impatient,
Though they never stood on ground, their speed was so amazing.

There was half a million people there of all denominations,
The Catholic, the Protestant, the Jew and Presbyterian.
There was yet no animosity, no matter what persuasion,
But fáilte and hospitality, inducing fresh acquaintance.

Anonymous

The Mother

I do not grudge them: Lord, I do not grudge
My two strong sons that I have seen go out
To break their strength and die, they and a few,
In bloody protest for a glorious thing.
They shall be spoken of among their people,
The generations shall remember them,
And call them blessed;
But I will speak their names to my own heart
In the long nights;
The little names that were familiar once
Round my dead hearth.
Lord, thou art hard on mothers:
We suffer in their coming and their going;
And tho' I grudge them not, I weary, weary
Of the long sorrow – And yet I have my joy:
My sons were faithful, and they fought.

Pádraig H. Pearse (1879 – 1916)

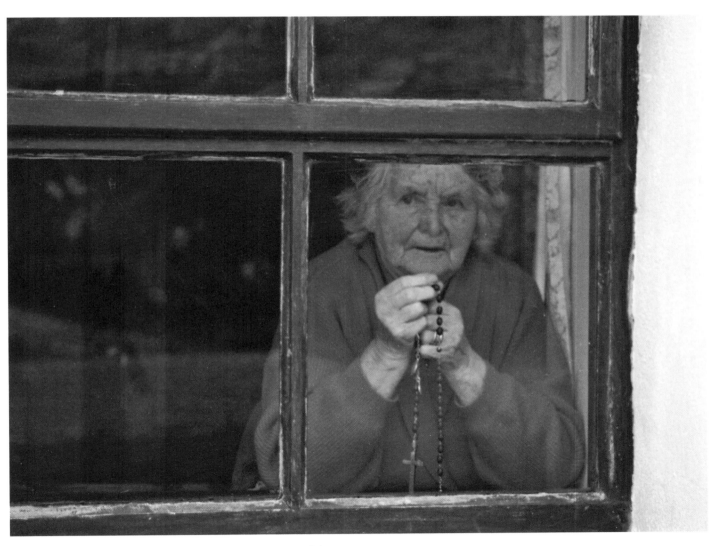

Mother praying for the safety of her fishermen sons.

Moon over Clare Island.

The Connemara Cradle Song

On wings of the wind o'er the dark rolling deep,
Angels are coming to watch o'er thy sleep;
Angels are coming to watch over thee,
So list to the wind coming over the sea.

Hear the wind blow, love, hear the wind blow,
Lean your head over and hear the wind blow.
Hear the wind blow love, hear the wind blow,
Lean your head over and hear the wind blow.

The currachs are sailing way out on the blue
Laden with herring of silvery hue;
Silver the herring and silver the sea,
Soon there'll be silver for my love and me.

Traditional Ballad

The West's Awake

When all beside a vigil keep,
The West's asleep! The West's asleep!
Alas! And well may Erin weep,
When Connacht lies in slumber deep.
Her lakes and plains smile fair and free,
'Mid rocks their guardian chivalry;
Sing, Oh! Let man learn liberty,
From crashing wind and lashing sea.

That chainless wave and lovely land,
Freedom and Nationhood demand;
Be sure the great God never planned,
For slumbering slaves a home so grand,
And long a brave and haughty race
Honoured and sentinelled the place,
Sing Oh! Not e'en their sons disgrace,
Can quite destroy their glory's trace.

For often in O'Connor's van,
To triumph dashed each Connacht clan,
And fleet as deer the Normans ran
Thro' Corrsliabh pass and Ardrahan;
And later times saw deeds as brave,
And glory guards Clanrickarde's grave,
Sing Oh! They died their land to save
By Aughrim's slopes and Shannon's wave.

And if when all a vigil keep,
The West's asleep, the West's asleep,
Alas and well may Erin weep
When Connacht lies in slumber deep;
But hark! A voice like thunder spake,
The West's awake, the West's awake!
Sing Oh! Hurrah, let England quake,
We'll watch till death, for Erin's sake!

Thomas Davis (1814 – 1845)

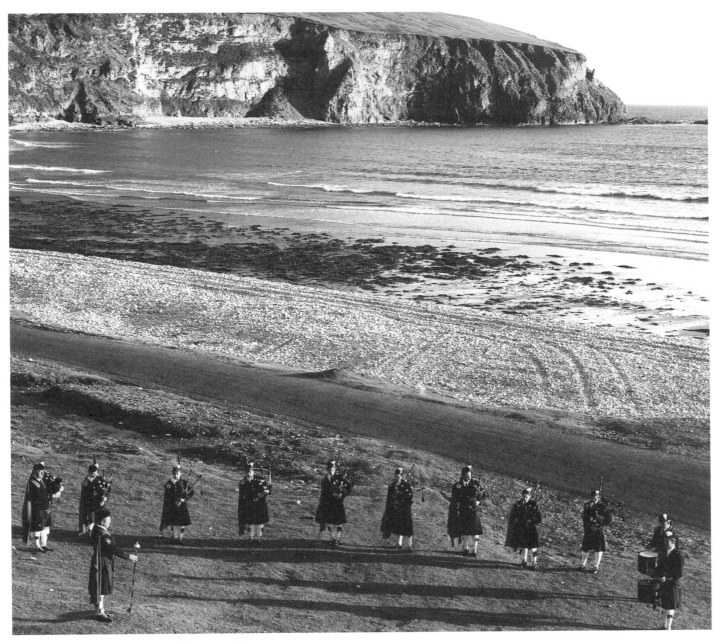

Dookinella Pipe Band.

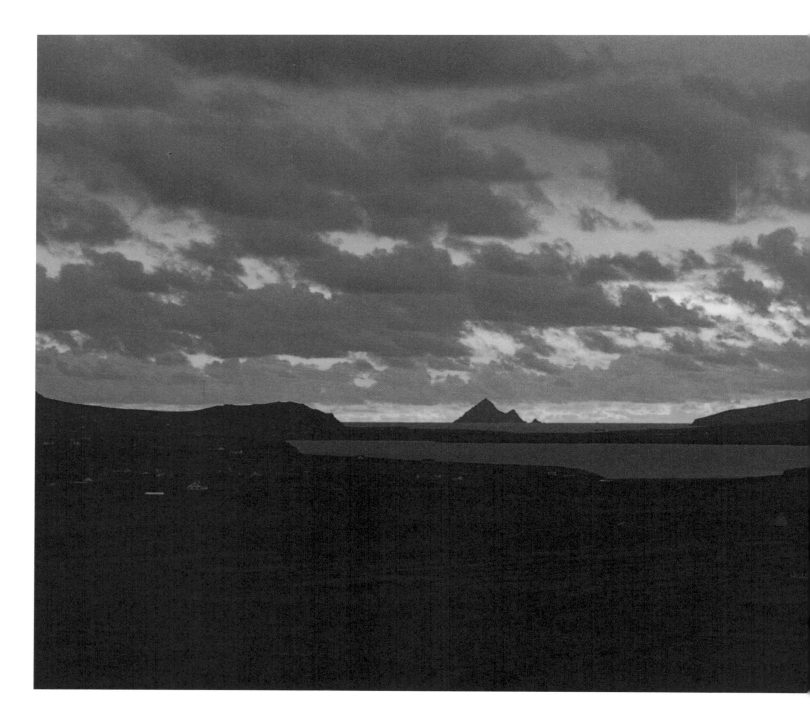

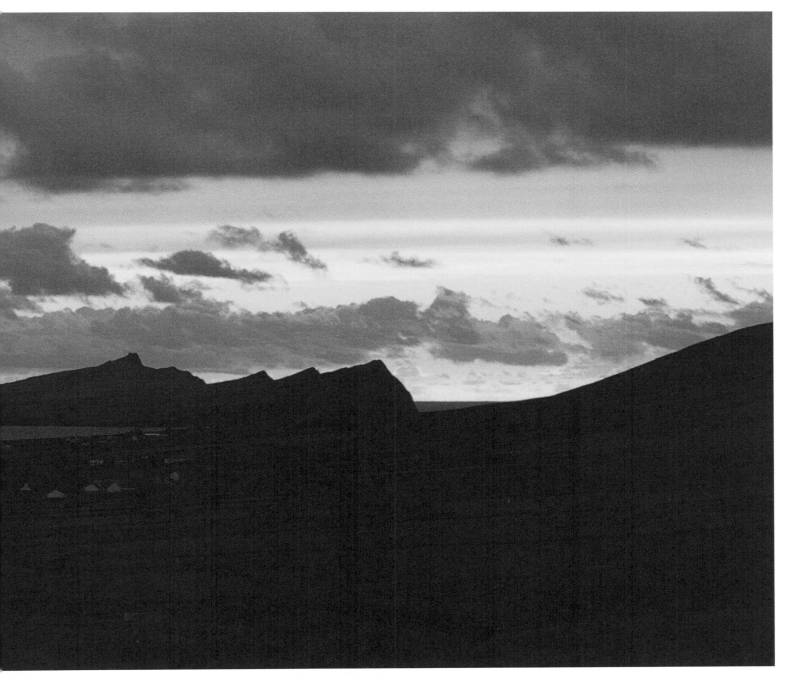

Inis Tuaisceart (Blasket island) and Three Sisters.

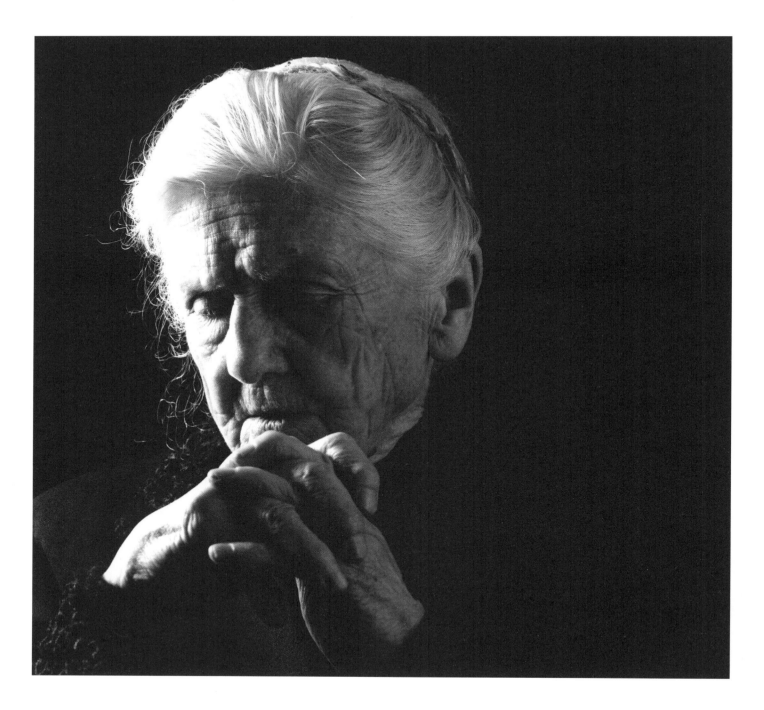

Index of Poets

Permissions

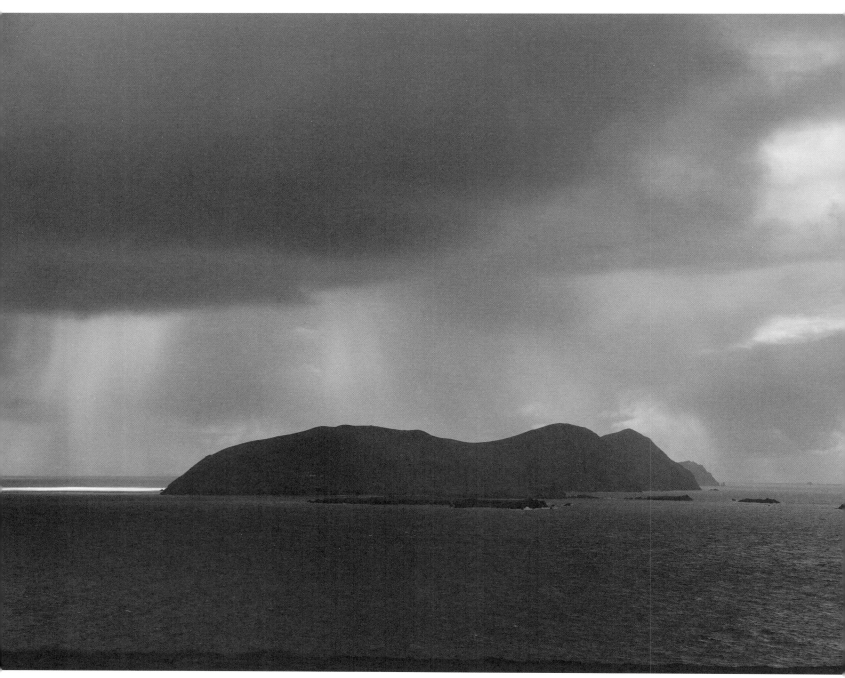

Great Blasket and Beginis in foreground.

Index of First Lines

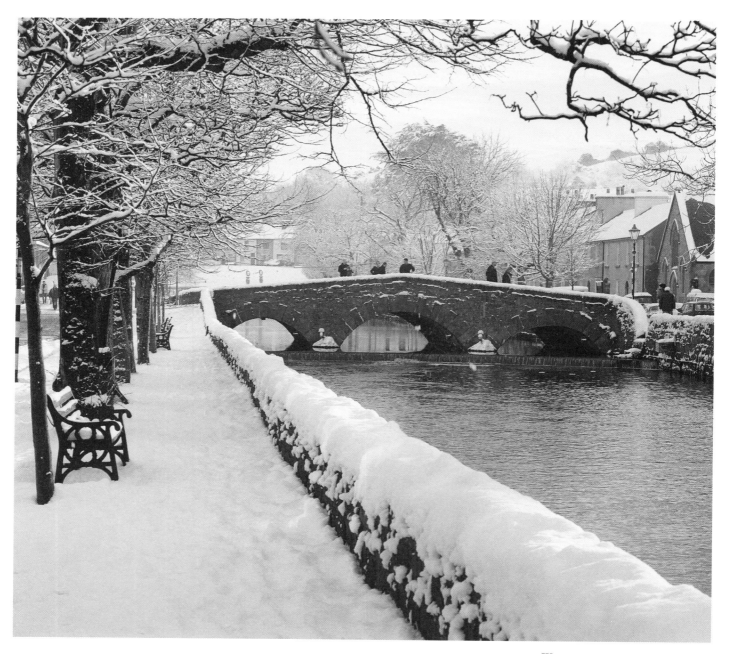

Westport.

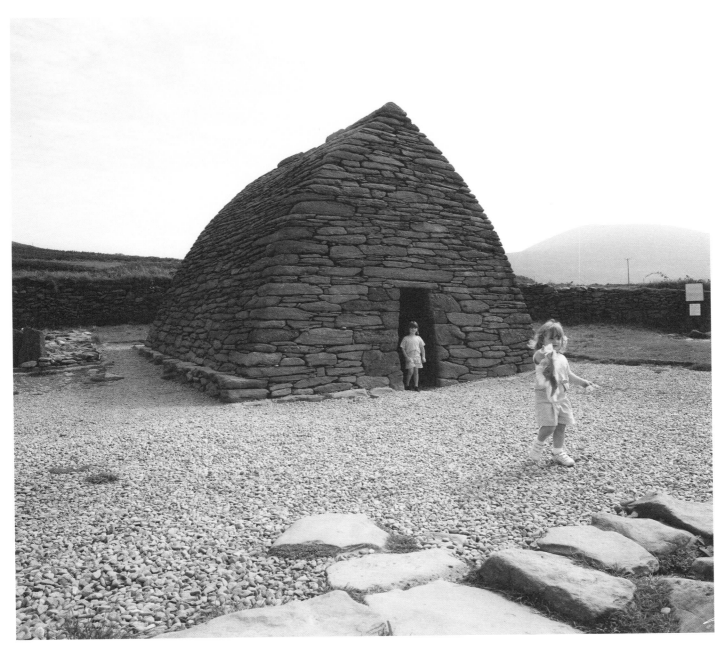

Gallarus Oratory.

Tír na n'Óg, Clew Bay.